THE ART AND MAKING OF

ULTRAMAN

RISING

THE ART AND MAKING OF
ULTRAMAN: RISING

ISBN: 9781835410714

Published by Titan Books
A division of Titan Publishing Group Ltd
144 Southwark Street
London SE1 0UP

www.titanbooks.com

FIRST EDITION: December 2024
2 4 6 8 10 9 7 5 3 1

Did you enjoy this book? We love to hear from our readers. Please e-mail us at: readerfeedback@titanemail.com or write to Reader Feedback at the above address.

To receive advance information, news, competitions, and exclusive offers online, please sign up for the Titan newsletter on our website:
www.titanbooks.com

A CIP catalogue record for this title is available from the British Library.

Printed and bound in China.

THE ART AND MAKING OF
ULTRAMAN
RISING

DREW TAYLOR

TITAN BOOKS

CONTENTS

FOREWORD

"FROM THE LAND OF LIGHT, FOR THE EARTH'S SAKE,
HE HAS COME, OUR ULTRAMAN."

In *Ultraman: Rising*, we meet Ken Sato, a new hero who has taken up the torch to defend our planet from evil. In the world of filmmaking, we meet another new hero who has taken up the torch to entertain and move audiences worldwide: Shannon Tindle. As the film's director, he and his team have lovingly created an action-packed, visually stunning, and moving addition to the *Ultraman* universe. That's no easy feat.

I first met Shannon in the sun-burnt hills of Valencia, California. He, along with his co-director John Aoshima, and I attended the California Institute of the Arts in the character animation program. John, who is an incredible artist himself, and I were juniors when we first heard about a new freshman with amazing character design skills. I remember seeing a design assignment Shannon did for one of the classes, which knocked me out. You know, like a giant *kaiju* getting hit with an energy blast. His design sense was amazing, his linework had a sophistication and passion that was well beyond his years. Somehow, the drawings were infused with the spirit of famous illustrators, old-school comic book artists, and animation legends such as Chuck Jones and Milt Kahl. Every line served as a tribute to all the influences that he loved, while also, simultaneously, being undeniably and irrepressibly Shannon.

But the fuel behind that singular power is his deep-rooted love for all the arts. Ask anyone who's collaborated with him (or nerd-ed out with him. Ahem, John?) – he possesses an encyclopedic knowledge of all things pop culture, from Shakespeare to Kurosawa to *Captain Carrot and His Amazing Zoo Crew!* (Look it up.) And out of all that, one of his greatest loves was *Ultraman*.

In the late 1960s, the original Japanese TV show called *Ultra Q* was lighting up living rooms and inspiring millions of people. Since then, *Ultraman* has built an internationally beloved universe of TV shows and movies. I like to imagine a young eight-year-old Shannon sitting in his pajamas, munching on freshly baked biscuits in his childhood home in Kentucky while watching the show, Ultraman firing off energy beams from his crossed hands straight into Shannon's eyeballs, igniting his imagination. Across the country, a young John Aoshima was infected with the same zeal in his Japanese/southern California upbringing. They finally met at CalArts and started a creative partnership that led them to Laika Studios, where John helped Shannon create the exceptionally beautiful film *Kubo and the Two Strings*. (Fun fact: John has one animated cameo in *Kubo* and two in *Ultraman: Rising*! See if you can spot him.) Even then, they were probably talking about *Ultraman*.

When I heard that Shannon would do an *Ultraman* film with John, I knew we were all in for a treat. But adding to the expansive tapestry of the *Ultraman* universe is no easy task. I privately wondered, with numerous storylines and explorations throughout the years, is there any space to create something new for the *kaiju*-fighting hero?

When I finally saw the film, it stirred up many emotions within me, because I could say yes! Not only did they find the new, but they did it by pushing the story into the real struggles of family, being a parent, being a son, and balancing work and family life. The movie succeeds by getting deeper into who Ultraman is and simultaneously showing us a mirror into who Shannon is as a loving father and as a wonderful husband. The film allowed me to connect to the same issues with my own family and try to find balance with all of it. And, of course, I was moved by John's connection to this narrative, with him and I being Asian-American and the identity issues that come with being part of two worlds. There are so many tasty ingredients made with love.

Shannon knows a lot about making things with love. I have a vivid memory of visiting him and his family, where he made me southern-style biscuits from scratch, using a cherished family recipe. The way he broke down the ingredients, describing how to get the perfect rise and flakiness, where in Kentucky you can get the right flour ("White Lily" – it's a thing), and the understanding that great food is only great if injected with that secret ingredient, love.

And, of course, great movies are injected with love, too.

This book contains the essential ingredients used to create the film, including character designs, environment explorations, color scripts, and a massive twenty-ton adorable baby *kaiju*. All for your cinematic dining pleasure. Shannon, John, and their incredible team undoubtedly created one of the best *Ultraman* feasts for audiences around the world.

PETER SOHN

► Color key by Marion Louw for Sequence 1600, "Sky Battle."

PRE-PRODUCTION

A BRIEF HISTORY OF ULTRAMAN

In 1966, *Ultraman* was born.

The television series began life as a successor of *Ultra Q*, which was created by Eiji Tsuburaya and developed by Toshihiro Iijima as the Japanese answer to western series like *The Twilight Zone* and *The Outer Limits*. Whilst the "Q" stood for "question", the "Ultra" in *Ultra Q* was a reference to Ultra C, an informal strategy utilized by the Japanese Olympic gymnastics team in 1964 and 1968. The term Ultra C is now used in Japan to mean an amazing or unbelievable feat. It would stick around for the next evolution of the series.

◀ Previous spread: Color key by Sunmin Inn for Sequence 0050, "Prologue."

▲ The original *Ultra Q* (1966) title screen, created by recording the mixing of a sand mural of the logo into signature swirls and then playing it back in reverse.

◀ Ultraman poses in preparation to fire his signature Spacium Beam. Note that the left arm always goes over the right!

It's important to note that Tsuburaya had giant monsters in his blood. Profoundly inspired by the original *King Kong*, Tsuburaya was later known as the God of *Tokusatsu*. Whilst literally translating to "special effects", *Tokusatsu* as a genre encompasses Japanese films and TV shows that heavily use practical special effects, often involving performers in suits and highly detailed miniatures. He co-created *Godzilla*, as well as developing the suits for the early movies, including Ishirō Honda's original *Godzilla* and the sequel *Godzilla Raids Again*. He also developed the effects for Honda's *Rodan*.

The visual language of the *kaiju* (giant monster) movie was almost wholly invented by Tsuburaya. When you think of Japanese giant monster movies, you're thinking about his incredible work.

While *Ultra Q* did include giant monsters, there was a push to do a series where they were the key focus. At the time of *Ultra Q*, Japan was going through what was later referred to as the "Kaiju Boom," with giant monsters being all the rage. Between *Godzilla*, *Gamera* and other smaller, more economically produced features gaining in popularity, monsters dominated the box office. For the follow-up, the team was urged, by the Tokyo Broadcasting System, to lean into the public's current love affair with giant monsters in a big way. They obliged.

Ultraman premiered just two weeks after the conclusion of *Ultra Q*.

Developed by Tsuburaya and Tetsuo Kinjo, *Ultraman* would forgo the "mystery of the week" structure of *Ultra Q*. Instead, the focus was on the titular character, a giant alien superhero, who takes over the body of a mild-mannered member of a science team that tracks intergalactic threats. The design of Ultraman is incredibly striking, with his iconic red-and-silver suit and giant saucer eyes, and his plight is equally compelling.

Each episode was created within a week, starting shooting as soon as the previous episode had aired. Given these extreme time constraints, several monsters were recycled from *Ultra Q* and episodes were shot on 16mm film, which was cheaper and easier to process, and which gave the look of the series an extremely identifiable texture and feel. New creatures were dreamed up by the show's production designer Tohl Narita, who also designed the character, Ultraman, himself. Further differentiating it from *Ultra Q*, *Ultraman* was aired in glorious color. Haruo Nakajima, another celebrated *Godzilla* veteran, played Neronga in episode 3 of the show, as well as supervising some stage shows.

▶ Gomess, the very first *kaiju* to appear in the *Ultraman* series, emerges from the mine in which it was hibernating. (*Ultra Q* (1966), Episode 1, "Defeat Gomess!").

▶ Jun Manjome and Ippei Togawa of Hoshikawa Airlines, and their friend, intrepid reporter Yuriko Edogawa of the Daily News, often found themselves at the center of incredible tales of mystery and monsters. (*Ultra Q* (1966)).

▼ Eiji Tsuburaya, the "God of *Tokusatsu*" and creator of the *Ultraman* series, instructs the hero he created.

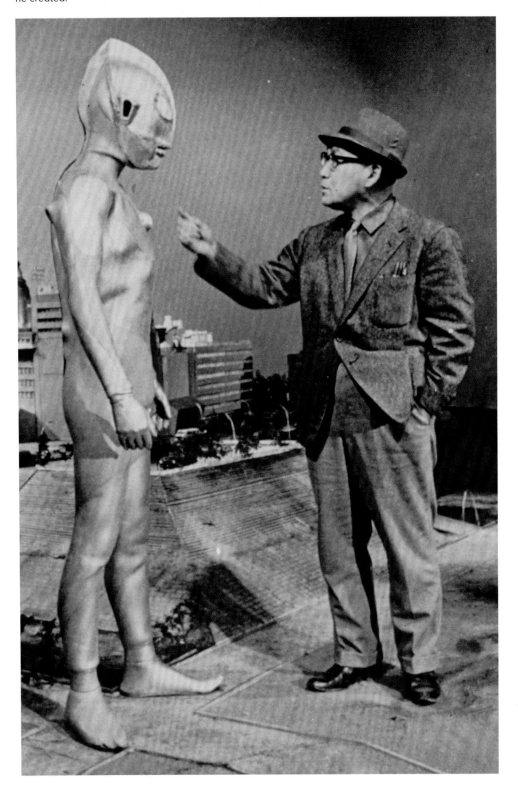

The show was an immediate success, with its popularity growing week after week. By the end of the first season's 39-episode run, it was a phenomenon. Just two months after its original Japanese run, it would air in America with a dubbed cast. By the end of the 1960s, the character would be known internationally. It would inspire countless series and spin-offs, not to mention a truly staggering amount of merchandise. By the 1980s, Ultraman would become one of the most licensed characters in the world and would continue to be reinvented and redefined, over and over and over again.

◄ The original "A Type" suit for Ultraman was the first vision of the legendary Giant of Light that most of the world ever saw, debuting in *Ultraman* (1966), Episode 1, "Ultra Operation No. 1."

◄ The "B Type" suit for Ultraman featured a smoother head and a slightly bulkier chest and was used from *Ultraman* Episode 14 "The Pearl Defense Directive" to Episode 29 "The Challenge into Subterra".

► The original maquette for the character that would become Ultraman, sculpted by Tsuburaya artist Akira Sasaki under guidance from Tohl Narita's original designs.

▼ A livid Neronga, denied the electricity it feeds upon, stomps a power plant into rubble. (*Ultraman* (1966), Episode 3, "SSSP, Move Out").

One of the people that *Ultraman* deeply impacted was Shannon Tindle.

"My first *Ultraman* memory was Sunday afternoons on WDRB Channel 41 back in Kentucky," Tindle said. He was four or five at the time. "I remember the first time, I think I came in late on an episode. He was in the middle of a battle and the color timer started going off. And I was like, 'What is happening?' When you see the image of him, he's so different than American superheroes at that time. The fact that he had a face, but it was a mask, but it's not a mask, and he's an alien. I think it is one of the strongest designs ever. And it was burned into my brain."

Tindle remembers noticing that the words coming out of the characters' mouths and the characters' lip movements were misaligned. "It was pop culture from another place. There's something that attracted me to that," Tindle said. At the time there was no way to get merchandise from the show in the US, and Tindle had no idea how big the character was around the world. There was also an extreme gap; he watched it as a little kid but didn't see it again for many years.

When Tindle moved to Los Angeles in 1997, he went to Little Tokyo. Ultraman was everywhere. "There are toys, and T-shirts, and hats. And I was like, 'Wait a second. What?'" It rekindled his love for the character and he started doing deep-dives, buying everything he could, including Japanese books that he couldn't even read and bootleg DVDs that collected volumes of the show which had never been properly released in America. "Watching it again, understanding it better now, understanding what broad reach it had, that's when the idea came: 'Wouldn't it be cool if I did something that's similar but different and see how it connects with an audience?'" Tindle said.

It was an idea that would, off and on, take up the next twenty years of his life.

▶ Ultraman grapples with the aggressive, monstrous form of the two-dimensional *kaiju*, Gavadon, aka "Gavadon B". (*Ultraman* (1966), Episode 15, "Terrifying Cosmic Rays").

▶ Pursuing the outlaw *kaiju* Bemular is what brought Ultraman to Earth – and his fateful collision with Shin Hayata – in the first place. (*Ultraman* (1966), Episode 1, "Ultra Operation No. 1").

MADE IN JAPAN

In the early 2000s, Tindle had graduated from the California Institute of the Arts and was living in Los Angeles. He was renting a house in Burbank with some other artists, just getting started in the creative industry, but already dreaming up big ideas of his own.

One of them was *Made in Japan*.

"It was inspired by my love for *Ultraman*, but I thought, 'What can I do to make it relatable in a broader way?'" Tindle remembered. He wanted to get people excited about a character who, although massive in other parts of the world, is considered more niche in much of the west.

"I thought, well, what if I humanized him a bit more, rather than making him this distant figure," Tindle said. "If I made him a parent, what would it be like to struggle to raise the child of his enemy? That is a huge character-building exercise. There's a lot of humility there and a lot of rethinking of how you view, 'who are your enemies, who are your friends?'"

Tindle began to pitch the project around town, first to Cartoon Network (who envisioned a much lower-budget version of the movie), then to Disney Television Animation, and finally to the Portland, Oregon-based stop-motion animation studio Laika, around the same time he pitched *Kubo and the Two Strings*. While Laika ultimately picked *Kubo*, Tindle continued to work on *Made in Japan*, refining and expanding upon it.

The project became even richer after Tindle had his daughter. "I was like, 'Okay, this is what being a parent actually feels like'. And a big component that was missing as part of that initial pitch was — you don't know what you're doing. None of us knows what we're doing when we have a child, and we need help," Tindle said. "We call our parents and our parents have all different kinds of advice to give. And much of that advice is going to be, 'I can tell you this, I can tell you that, *but there are no rules.*'" Tindle soaked up all the advice and experience, ultimately using it to decide, "Okay, let's make it a film about parents and children."

While Tindle admitted that he doesn't normally work from theme, finding it "restrictive," and preferring to "write some experimental scenes, get characters in the room together, get to know them, maybe do some drawings," he constantly gets asked what the theme for a project is, by studios and executives hungry to boil something down to its simplest, most sellable assets. "But as I explored the question, what started to come out, was that parents learn as much from their children as their children learn from them. And that mutual understanding and learning became the thing that was most interesting to me," Tindle said.

Tindle wants the projects he works on to be visually appealing and have a certain scale to them, complete with intricate world-building. But he admits that his core ideas, nestled at the heart of every project, are very simple and relatable.

▶ Shannon Tindle's first concept for *Made In Japan*.

▼ Following spread: Well before *Ultraman: Rising*, Ryan Lang painted this concept piece of Gigantron rising over Tokyo Dome.

Kubo and the Two Strings, he said, "is about a kid who wants a 'normal' family – a mom who isn't struggling with dementia, a father who isn't dead. He's reunited with them, but not in the way he's expecting. And when he realizes it, he loses them again. That's what that film is." Sure, it has giant skeletons, and talking monkeys, "But it's really about realizing the value of the life we've been given," Tindle said. Conversely, *Made in Japan* "was about connecting with parents and children, but also the struggles and being very honest about what those struggles are. All of that stuff started to really gel together."

The clock, too, was ticking. Tindle had left Laika and *Kubo and the Two Strings*. He had a stopgap project for Google called "On Ice," a short film that served as an expansion of an uncompleted CalArts thesis project he had been working on. But he knew that he had to figure out what to do next.

He started pitching again – including *Made in Japan*.

Pam Marsden, the head of production at Sony Pictures Animation, reached out to Tindle and invited him to fly down (at the time he was still living in Portland). "Hey, your name's been coming up a lot and we were interested in talking to you," Tindle remembered Marsden saying. At around the same time he was also approached by Kristine Belson, who was leaving DreamWorks Animation (where Tindle worked on *Turbo*) and was becoming President of Sony Pictures Animation. She was eager to speak to him too. As was Mike Moon, an executive Tindle knew from Disney, who was now at Sony. Moon had been a supporter of *Made in Japan* since Tindle had first pitched the idea to Disney.

Marc Haimes, with whom Tindle had worked on *Kubo and the Two Strings*, was recruited to help on the story about an everyday guy who has a secret identity as a gigantic superhero called Gamma Man. After defeating a terrifying monster, he is then forced to raise that monster's child.

Haimes had worked with Tindle on several projects, including a movie that was sold to Reel FX, the animation studio and effects house based out of Dallas, Texas. "This was before people really started to believe in animation as a medium that could tell a different kind of story," Haimes remembered.

When Tindle submitted the treatment to Sony, everyone, including Belson and Tom Rothman, chairman and CEO of Sony Pictures Motion Picture Group, loved it. "They said, 'All right, we're going to bring you over. You're the director. Let's get going,'" Tindle recalled. "Mike Rianda was doing *The Mitchells vs. the Machines*. Peter [Ramsey], Chris [Miller], Phil [Lord], and Bob [Persichetti] were doing the first *Spider-Verse*. They were all there at the same time. It was a really exciting time to be at Sony Animation."

Sony gave *Made in Japan* a primo release date, timed to the opening of the 2020 Olympics in Tokyo, Japan. It was all systems go.

But cracks soon started to form. Executives grew uncomfortable when *Incredibles 2* was released in 2018 and featured a scene where Jack-Jack turns into a giant baby. Sony pulled the release date. Tindle was forced to let the crew go.

"As often happens in movies and in relationships, there's an extra six or seven months there where who knows what anyone is doing. And then it kind of dies," said Haimes. It seemed like that was the end of *Made in Japan*.

▲ Concept art by August Hall showing Emi hatching following Gigantron's death.

▼ Sunmin Inn's concept art shows how, even in the film's earliest iteration, Ken struggling to raise Emi by himself was central to the plot.

◄ Concept art by Paul Lasaine with Ken finally
joining forces with his father to raise Emi.
Fun fact – this piece was used on the "Happy
Holidays" card distributed to the crew during
Ultraman: Rising's first year of production at Netflix!

Until Tindle went out to dinner with some old friends.

Tindle reached out to Jorge R. Gutierrez, the filmmaker behind *The Book of Life*, to grab a bite. He also invited Peter Ramsey, who brought Bob Persichetti along. Mark Osborne, director of *Kung Fu Panda*, was in town so he came too. Tindle posted a photo to social media with the blustery caption: "Maybe we should start our own animation studio." That same night he got an email from Melissa Cobb, whom Tindle knew from DreamWorks but who was now at Netflix, saying, "I'm calling your bluff, Shannon." She asked if he could get the same group together the following night. He did.

The team met at the Netflix building and walked over to what they referred to as The HUB, which was the old Siren Studios lot. The building was essentially deserted. The only thing there was legendary Disney animator Glen Keane's laptop. Keane had just started work on his debut feature for Netflix, *Over the Moon*. "They put up a picnic table and ordered a bunch of pizzas,." Tindle said. He was seated next to Cobb. She asked him, "What if we made your movie here?" He demurred and said that was a conversation that Sony would have to have with Netflix. "I sold the idea to them. I don't have any power in that situation. I would love that. I'd love to keep it alive," Tindle said.

Still, he pitched to several more executives at Netflix, before being asked to pitch to Cobb's larger team. Tindle walked into a room of a dozen executives. They had already read the script and loved it. He also met someone new – Aram Yacoubian. At the time, Yacoubian was managing outside acquisitions and partnerships. And the week before he had met with Tsuburaya Productions, the legacy company that currently controls the rights to the *Ultraman* character.

Tsuburaya, Yacoubian said, was interested in making a big-budget animated feature. Would Tindle be interested in turning *Made in Japan* into an *Ultraman* film? "I said, 'Well, Nerd Me is really excited by that idea. Producer/Director Me has spent a couple of rough years trying to get the thing made the way that I want to,'" Tindle said. "I knew that they were very protective of that character and that there had been all kinds of lawsuits with people claiming ownership of it, which is why I said, 'I just don't want to get into that mess.'"

Cobb asked if Tindle wanted to go to Japan with them and pitch to Tsuburaya directly. Tindle, still skeptical but not one to turn down a free trip to Japan, agreed. They flew out on October 26, 2018, the night the Los Angeles Dodgers played the Boston Red Sox during what would become the longest game in World Series history, at seven hours and twenty minutes. Just before midnight, as their red eye was about to leave from Los Angeles, the Dodgers won the game. It was a good omen.

Tsuburaya "absolutely loved" the *Made in Japan* pitch. Netflix was fully on board. "And then we started the very long process of getting it out

► August Hall depicted Emi's first night at home with Ken.

of turnaround with Sony," Tindle said. In that time Tindle began developing *Lost Ollie*, with Shawn Levy's 21 Laps and Netflix. The idea was that Tindle would direct and run *Lost Ollie* as a limited series and then, during the show's post-production, he would retrofit the *Made in Japan* script, incorporating *Ultraman* lore like the science team. "You have all these other elements and rich history. You can pull from that legacy and incorporate it into the film," Tindle said. "I wanted to do that."

But when it became clear to Tindle that he would have to juggle both *Lost Ollie* and *Ultraman: Rising* at the same time, he delegated duties. If he took on *Lost Ollie* himself, he would have to lay off the *Ultraman* team (again) for five months. "We weren't a huge crew at that time, but they're my family and I don't want my family to be looking for work," Tindle said. "And I might not be able to get them back." Tindle turned to Ramsey, who would direct all of *Lost Ollie*. Tindle had two offices at Netflix and would shuttle back and forth. He remembers a particularly hectic day when he was asked to re-write a pivotal *Lost Ollie* scene while they were shooting (snow had forced them to change locations), while at the same time he was supervising the storyboarding of *Ultraman: Rising*. "That's what my life was early on with that," Tindle said. He was also developing a prequel series and a pre-school series with the team, both based on the world of *Ultraman*, both of which were ultimately put on the backburner.

But how do you turn a completely unrelated script into an *Ultraman* opus? Talk about a heroic task.

▶ Concept art by Paul Lasaine of Emi bouncing her way through Los Angeles, creating chaos and destruction in her adorable path (sound familiar?).

▲ Concept art by Marcos Mateu-Mestre of a since-omitted sequence in which two unsuspecting fishermen see Gigantron prowling her way towards the city.

▼ Early environment design by Marcos Mateu-Mestre of Gamma Man's secret base, which went on to be used as the template for Ultraman's base.

WRITING
AND REWRITING

 Marc Haimes grew up in Bethesda, Maryland. At the time there were three television channels. Fox didn't exist yet. There were also a couple of channels that you could *sort of* get if you knew how to futz with the television's bunny ears. "There was Channel 50 where you literally had to stand with the antennas, adjusting them and contorting yourself. This was before yoga. You had to contort yourself in order to watch *Ultraman*," Haimes remembered. "And I, as a young kid, went through all these different contortions to try to watch this amazing show." He had no sense of continuity. Channel 50 only came through in black-and-white. "I remember *Ultraman* as super grainy and staticky because that was the only way I could watch it," Haimes said. "I knew some of the monsters."

When *Mighty Morphin Power Rangers*, another localized version of a Japanese series, gained popularity more than a decade later, Haimes felt a twinge of *déjà vu*. "I was like, 'Oh, that was the thing that I was obsessed with when I was a nine-year-old in Bethesda, Maryland,'" Haimes said.

▲ A Main On End card designed by Sunmin Inn and Kojo

▶ Shannon Tindle's screenplay for a page of Sequence 1700, "Gigantron's Egg."

EXT. BEHIND ULTRAMAN - OVER THE PACIFIC - SAME TIME

A cluster of missiles spiral toward Ultraman. He turns, races toward Gigantron- his ENERGY SHIELD flickering- TOO LATE.

> MINA
> Danger. Take evasive action.

The missiles spiraling- closing in-- **BOOM!**

EXT. TOKYO STREETS - SECONDS LATER

A ball of fire lights up the night sky, flickering across a gathered crowd. SATO pushing through it. His face twisted in horror gasping as a trail of light streaks from the explosion.

EXT. ABOVE THE PACIFIC - SECONDS LATER - CONTINUOUS

FALLING WITH ULTRAMAN AND GIGANTRON. Engulfed in flame.

THOOM! They smack into the sea, sending a plume of water high into the air.

CLOSER NOW as the water settles, Ultraman FLOATING, seemingly LIFELESS. We hold for an alarmingly long BEAT.

> MINA (V.O.)
> Ke--. Ken. Ar--. Are you OK?

Ultraman finally GASPS for air. Scorched but ALIVE. Disoriented, he doesn't see the large shape LOPING behind him.

GIGANTRON straining, reaching, craning her neck toward the SPHERE. Bobbing in the surf. Its homing beacon still flashing-- A last desperate effort from Gigantron and then--

--she rests her head on THE SPHERE and DIES.

A beat of mournful silence, Ultraman staring, in shock, then…

The SPHERE begins to SINK. Ultraman treads toward it. Lifting the sphere. Inspecting it. Then, it POPS OPEN with a hiss, releasing a GIANT GLOWING EGG.

Ultraman STARES. Overwhelmed, gently cradling the egg against his chest. SILENT, then… A CRACK. A small one, but the egg wobbles and it grows into a fissure. Ultraman GASPS.

> ULTRAMAN
> No. Nonono.

While he was never able to recall the particulars of the series' sometimes complicated mythology (undoubtedly due to the fuzzy, out-of-order nature of his viewing experience), *Ultraman* stayed with him on an emotional level. "There was a humility to it that you didn't have with other superheroes," Haimes said. "I always understood the emotion that was specifically *Ultraman*."

John Aoshima, who started on the project as the head of story before becoming co-director, also worked on *Made in Japan*. His first exposure to the character of Ultraman was in an early-1980s manga called *Dr. Slump* that featured a young cyborg girl who modeled her existence after Ultraman. It was created by Akira Toriyama, who passed away in March 2024. Aoshima was four or five when he discovered the character. "I came across the manga at my grandparents' house and I started reading it and I was like, 'Why is she so obsessed with *Ultraman* and what is *Ultraman*?'" said Aoshima, who grew up in Japan with his grandparents from age four to eight. "Soon enough, I started to find other books around the house; they must've been my cousin or my older brother's books. And once this giant silver and red hero popped onto my radar, it was immediately like I started recognizing it everywhere."

He recently saw a photo of himself, as a child, with an *Ultraman 80* T-shirt on. It was personalized with Aoshima's Japanese name.

When Netflix got the rights to *Made in Japan*, the team's work began. While the fundamentals of the story remained the same, they were able to draw upon the lore of *Ultraman* – including reinventing an essential piece of the mythology.

"One of the big conceptual things that we do that's a break from tradition with the character is that the science team are the bad guys in this one," Tindle explained. In *Ultraman: Rising* the villain is Dr. Onda, who persecutes monsters as part of the KDF – the Kaiju Defense Force. Different science teams were a hallmark of the original series, but this iteration had never appeared. Getting Tsuburaya's approval on their change in motive was tricky. They asked if there could be a member of the team who is the voice of dissent.

This feedback led to one of the more powerful moments in the film, when Dr. Onda and Captain Aoshima are talking about what happened to Onda's family. Captain Aoshima says, "I wholeheartedly believe in our mission, but is there no other way?" And Onda says, "I don't enjoy this task...but I've learned that hard decisions must be made to protect those we love." Onda is a scientist, not a hunter. He doesn't want to do these things. But he has to so that others don't share his experience of losing his wife and child. "That scene came purely out of Tsuburaya saying, 'Hey, could you please give a bit more context for the KDF and not paint them all as the bad guys?'" Tindle said. He thinks of the scene as "one that I'm proudest of in the writing," and credits the team at Tsuburaya for inspiring the sequence.

▶ During John Aoshima's travels while working on *Ultraman: Rising*, he'd bring a small Ultraman figurine along and snap photos. Here he is in front of Tokyo Dome, when he, Shannon Tindle, Tom Knott, Makiko Wakita, and Aram Yacoubian attended a Tokyo Giants game.

▲ Bringing New Tokyo Dome to life was a "Giant" task, which involved creating a visual development build, modeled by Jason Scheier.

▼ Once she had a model to work on top of, Minako Tomigahara was tasked with depicting which signage would be included, and where to place it.

Makiko Wakita, who would go on to become the production supervisor for story and script, remembers spotting Shannon Tindle in the hallways of Netflix. She knew that *Ultraman* was coming to Netflix, and so made the classic Ultraman crossed-arm gesture, which he then flashed back at her. They spoke the same language.

She told him that she was a pro at pre-production and was working with a Japanese company doing a lot of IP (intellectual property) development. "Japanese IP is one of the most challenging things to translate," Wakita said. "Not just translation, but it's more conveying the essence of it and cultural differences. There are a lot of nuances in there." Wakita was born in Japan in the early 1980s, during a drought of *Ultraman* content (she does still remember a noodle commercial featuring the superhero) but grew up in the United States. She kept up with Japanese pop culture, however, constantly reading manga. "I thought with the pre-production in mind and development, I could definitely help in general," Wakita said.

Soon enough, Wakita was joining the nascent production team, alongside Tindle, Aoshima, and producer Tom Knott. In this initial development and writing phase, another big question they addressed was how much they should dip into the labyrinthine (and occasionally dizzying) well of *Ultraman* lore. This is, after all, a character that has existed for nearly six decades and is still going strong. How do you decide what to use, and what to discard, when introducing the character to a new generation?

Aoshima remembers the trip to Japan as being key to understanding what was important to carry over to their new version of *Ultraman*. "Every day we were meeting with that team and really getting the full download of not just the history of it, but what they were trying to bring back to

▼▶ These are pages of the comprehensive Style Guide created by Marcos Mateu-Mestre (linework and design) and Sunmin Inn (color and stylization), which was handed off to ILM so they could build scalable systems to achieve *Ultraman: Rising*'s unique look.

the spirit of *Ultraman*," Aoshima said. He and Tindle were fans of the original Showa Era of the series. "If we're taking the opportunity to take *Ultraman* property to the rest of the world and introduce it to new fans, let's start with that and just relaunch it that way," Aoshima remembered the Tsuburaya team telling the team from Netflix. "It was a really interesting time to discover what *Ultraman* means."

Whilst overall a success, Wakita remembers some initial misunderstandings. "We would just go back to the hotel and talk about, 'Okay, this is what I caught. I think this is what they're trying to say,' versus everybody trying to be polite." The next day they would come back to the office "super fresh." "There was this one moment I totally remember, when we just cracked it – their team and our team just meshed so well that we started crying," Wakita said. "This was an incredible moment of – you get me, I get you." (They bonded over a blog post where the author wondered what Ultraman would have done in the wake of the tsunami and subsequent nuclear meltdown in Japan.)

In that moment the Tsuburaya finally understood what *Ultraman: Rising* could be. And more importantly they trusted Tindle and Aoshima, not just as filmmakers, but ambassadors for *Ultraman*.

When working on *Made in Japan*, Haimes remembered trying to reference *Ultraman* without creating any "ripples" that could get them in hot water. The transition to being able to actually play with the character that had inspired them all so greatly generated all sorts of new complications.

"There were so many things that were working that weren't getting bogged down in the character and in the lore," Haimes said. Haimes said that he and Tindle both enjoy world-building and that a cornerstone for both of them was Alec Guinness' line as Obi-Wan in the first *Star Wars*, where he tells young Luke Skywalker that he fought with his father in the Clone Wars. "It was one line that kind of gave you this sense of offscreen space. If you move the camera six inches to the right, there's another creature with another story that you could tell," Haimes said. "And I think that's kind of how Shannon looks at the world. It's certainly how I look at the world. It's one of the reasons we get along, [the shared idea] that everyone has a story." Dr. Onda, for instance, is the villain of *Ultraman: Rising* but, Haimes notes, is the hero of his own story.

Haimes remembered a test screening for the film in Chino Hills. There was a wide spectrum of people recruited for the screening. And Haimes found a miraculous truth when they started talking about the movie afterwards – those that knew nothing about *Ultraman* and those that knew everything about *Ultraman* were equally pleased.

"The people who knew nothing about *Ultraman* were like, 'Wow, this guy's cool. I like how he hit the ground running. I

never felt like I was catching up or I was out of the loop,'" Haimes said. "And the people who knew *Ultraman* said, 'You know what? That was a great *Ultraman* story. I didn't need to nerd out on some of the stuff from the TV series and the lore because there was enough there for me, and there was an emotional story that I was invested in.'"

Although, they later found out that there was a little bit of table-setting that needed to be done. The suggestion came from filmmaker Guillermo del Toro, an avid fan of the property and someone who made one of the best giant monster movies of all time in *Pacific Rim*. It was del Toro who made the note that there should be a brief montage, explaining who Ultraman is and what he is doing protecting the city from the monsters.

"That's a *kaiju*, not a hero, but not a villain either," our hero Ken explains, over footage that looks like it was captured on a camcorder. "There he is. That's our hero. Ultraman. For thirty years he protected us, using his amazing powers to keep everyone safe. He called it *maintaining balance*. I just called it *cool*."

What makes the sequence so striking is that it's just the voiceover and music. There are no sound effects, no roaring *kaiju* or laser-beam sound effects. It was a suggestion by sound designer Randy Thom and one that Tindle treasures. "To me, it makes it a lot more like a kid commenting on home movies," Tindle said.

Tindle said that the relatively mythology-free approach to the character, maybe surprisingly, didn't upset Tsuburaya. "It was less about adding lore and more about not damaging things, not out of expectation, but what *Ultraman* is about and what he represents," Tindle said. There was a question, for example, of whether Ultraman kills the fish that he feeds to the baby *kaiju* now in his care, since the character, historically, doesn't kill. But that was quickly resolved. And besides, the baby kills the fish, really. *Kaiju* get away with anything.

"They gave me so much trust and freedom, far more than I think anybody else would've at any of the other big studios handling one of their marquee superhero characters," Tindle said, still in disbelief.

There were several things that helped the team get the okay to make a project that wasn't beholden to the pre-existing *Ultraman* mythology. First and foremost was the fact that everybody loved the story, and the feeling was that it was a great script about kids and parents, separate from the *Ultraman* mythology.

Also: the character's own evolving lore.

"The thing about Ultraman is the canon changes constantly," Tindle said. "They've tried to make it a little more cohesive over the years." Even the basics of who Ultraman is – does he share a symbiotic relationship with a human? Is he an alien? Does he have the Beta Capsule? Sometimes. (The

▲ Mark Garcia storyboarded the action-packed Sequence 1600, "Sky Battle."

▶ Marcos Mateu-Mestre provided tone keys for the sequence, which focused on the lighting and composition approach.

Ultraman in *Ultraman: Rising* does not.) The reason for these variations is down to the Japanese media-mix strategy, wherein a single intellectual property may be dispersed across multiple media outputs and interpreted by various artists.

However, there are always a small number of constants that define the IP. These elements were also important to the *Ultraman: Rising* team: the science team; the look of Ultraman's silver and red pattern (more on that in a minute); the way that Ultraman transforms, saved for the end of the movie "when Ken really earns it," as Tindle said.

"As long as we had enough of the elements that would be recognizable to fans, everybody was happy," Tindle said. "From the beginning, I wanted to get people interested in a character like Ultraman because I felt there were people missing out, but I [didn't know] whether they didn't have access to it or whether it didn't appeal to them." Tsuburaya, too, wanted to extend the audience. An engaging emotional story, worked through with just the right amount of mythology from the original series, was agreed to be the perfect combination to draw in new fans whilst satisfying the old.

◀ Gabriel Gomez explored the film's stylization in a concept piece for an epic shot in Sequence 0300, "Meet Ultraman," with final edits by Marcos Mateu-Mestre.

REDESIGNING ULTRAMAN

One of the most iconic, easily identifiable designs in the history of pop culture, Ultraman was originally designed by Tohl Narita and clay sculptor Akira Sasaki after the original conception of the character (which would eventually be developed into Ultraman's foe Bemular) was abandoned.

For *Ultraman: Rising*, the task of redesigning the character would fall to director Shannon Tindle and Keiko Murayama, the character art director. Simple enough, right?

Murayama grew up in Japan and was keenly familiar with the Ultraman character. "As a Japanese person growing up in Japan, it's kind of like asking an American person, 'Do you know Superman?'" Murayama said. She even dug out a photo of herself, when she was three or four, wearing *Ultraman* gear. And that iconic mask and wild hair went on to inspire another character's design, Ami Wakita's daughter, Chiho.

She said that she was nervous about designing a new version of the character and absolutely felt the weight of what Ultraman meant. "I was like, 'Oh my God, do I need to do this?' It's such a responsibility," Murayama said. "And I know there are so many hardcore fans in Japan, as well as worldwide. And then if I don't do it right, I think they're going to be so upset."

Ultimately, she said, after a bit of body shape exploration, Tindle took over the Ultraman design. "Thank goodness," Murayama said.

In some ways, this new Ultraman was a re-adaptation; Tindle had used Ultraman as the inspiration for the Gamma Man character in *Made in Japan* years earlier. "Proportionally, they're not that different," Tindle said. "I've drawn Ultraman a lot, but I'd already done some trial and error on the Sony version with Tony Siruno."

Tindle was in Japan when he saw a presentation by Hideaki Anno, the creator of *Neon Genesis Evangelion* (and the writer/producer of *Shin Ultraman*, a live-action take on the character that followed Anno's masterful *Shin Godzilla*). The presentation was on *Return of Ultraman*. "You won't hear a lot of people talking about *Return of Ultraman* or Ultraman Jack as he's known," Tindle notes. "But [Anno] is a scholar of *Ultraman*, and you can see the influence of *Ultraman* on *Neon Genesis Evangelion*." When designing his version of Ultraman, Tindle borrowed from *Neon Genesis Evangelion*, just as Anno had borrowed from Tsuburaya and *Ultraman* for *Neon Genesis Evangelion*. Truly, some circle of life stuff.

Tindle loved the lanky proportions of *Neon Genesis Evangelion*'s Evas, the long-limbed, bio-mechanical robots that populate the series. "There's an alien vibe to it and Ultraman is not from here," Tindle said. There was also a desire to take the classic red-and-silver color scheme and slightly update it. Tindle and the team made the pattern a little bit more angular. But they were sure not to adjust it too much. "It's probably my favorite costume design ever."

▶ Concept art by Sunmin Inn, which was later developed into the first image released by Netflix for *Ultraman: Rising*.

▲▼ Tony Fucile created pose studies for several characters. These were used as the basis for ILM's early animation tests, to ensure the rigs were ready for anything Ultraman might throw at them.

▲ Shannon Tindle's revised pattern for Ultraman, as seen in the final film.

ROUGH PAINTOVER DONE TO SEE LINES CLEARER. NOT SURFACING REF

EYE OPTIONS
① BLUE LINE
→ SHANNON'S PICK (EYE)
→ JOHNS EAR PICK

② WHITE LINE
→ SHANNON'S EAR PICK

③ WHITE LINE BLEND, SLIGHT BLUE
→ JOHNS PICK (EYE)

④ WHITE LINE BLEND THICK

▲ Ultraman's eyes were a crucial element for his animated performance. Here, Sunmin Inn proposed a few treatments.

▶ Sunmin Inn's style guide for Ultraman's look, which was achieved by painting over the approved visual development sculpted model, provided by Michel Guillemain.

► Ultraman crouches amidst rubble in Akihabara, before charging back into battle against Neronga.

Tindle is quick to point out that the original mask is based on gray aliens — the alien species cited often in real-world abduction cases that often pop up in pop culture, most notably *Close Encounters of the Third Kind, The X-Files,* and based-on-true-story narratives like *Communion* and *Fire in the Sky.* The mask from *Ultraseven,* the third installment in the series, is "a little bit more inspired by Mesoamerican art."

"When it came to him, it really was just making sure that I was pushing the proportions, because sometimes when you're designing, especially when you're doing a redesign of a classic character, you tend to be more conservative," Tindle said. "And I was constantly, and this was across the board, challenging both myself and our other character designers on the show to push proportions."

Another inspiration Tindle brought up was Leiji Matsumoto, the legendary creator of *Space Battleship Yamato* and *Galaxy Express 999* (among other things). "Other than me, our design team were all Japanese, so I could say, 'Leiji Matsumoto,' and they knew exactly who I was talking about, and they knew exactly what art to look at," Tindle said.

The decision to base *Ultraman: Rising's* design on the original series was also strategic. "Even if you don't know anything about Ultraman, there's a good chance you've seen him," Tindle said. "It was like, 'Okay, how can I do it in a way that feels just a little bit updated?'" The intent by the design team was to make sure it was "classic."

While they knew that they weren't going to have facial expressions — like the original, live-action series — there was also a desire

▼ Ultraman flies an injured Emi away from Tokyo Tower and toward his Ultrabase.

▶ Several unique poses of Ultraman were created for use in consumer products and promotional materials — and now, books!

to give the design more soul. "When you look at his eyes, there's that circle of light in there, so we can use that to show where Ultraman is looking and how he's feeling" Tindle said. The team produced an animation test, where that light was used directionally. It was a slam dunk.

But that's not all.

"The other element that you have to have, at least for me, on any Ultraman design is (even though there's not a zipper, and I don't have to include a zipper on a costume) that fin down his back; it's a part of every one of the suits," Tindle said. "I incorporated it into the back of his head just as an additional design and had it taper off by his back because I wanted it to pay homage to that. It's one of those things that was left there, I think, just to hide the zipper, but it's become one of those essential elements of the design. You've got to put it in there."

Ultraman's color timer, which has become controversial in recent years thanks to Anno's decision to keep the design out of *Shin Ultraman*, also became a topic of discussion. "There was a lot of talk about what the color timer means. Does it go off after three minutes?" Murayama said. "It is cool in this movie that the color timer is more of a relationship to how he feels *inside*, under the Ultraman skin." The timer in *Ultraman: Rising* is directly related to Ken's state of mind, which is indeed cool.

Of course, this is an Ultraman movie with more than one Ultraman. "Ultraman didn't take that long. Where it

got interesting was Ken's dad," Tindle said. The team got some pushback from Tsuburaya, who argued that the Ultra characters don't look like their human counterparts, after Tindle presented a "Dad-bod Ultradad." Tindle's counter was that he didn't want two characters on screen that look exactly the same. He wanted to show the generational gap between the two versions of the character. "Also it's entertaining and funny," Tindle said. Tsuburaya did ask him to pull back on a rather jovial pot belly. Tindle obliged, leaning into a more Jack LaLanne, barrel-chested look for the elder Ultraman, referring to the fitness guru and motivational speaker who gained popularity in America in the 1950s.

Then there was Ultradad's mustache which, incredibly, has its basis in *Ultraman* lore. (This is when it helps that the filmmakers are also walking *Ultraman* encyclopedias.) Tindle points to Ultraman King, another character in the mythos, who has the "Burger King mustache and beard sculpted into the Ultraman mask." He was introduced in *Ultraman Leo*, the seventh series in the franchise, which ran from 1974 to 1975. "Everybody gets a chuckle when they see his mustache on there," Tindle said.

When he asked the team from Tsuburaya which character from *Ultraman: Rising* they would most want the toy of, Ultradad was the clear standout.

We want an Ultradad toy too.

▶ Shannon Tindle took feedback from Tsuburaya to heart, and made Ultradad more barrel-chested.

▼ Ultradad concepts by Keiko Murayama leaned into his "Dad bod."

46

▼ As with Ultraman, Tony Fucile was tasked with exploring Ultradad's full range with extensive pose studies.

THE
BABY

In *Ultraman: Rising*, Ultraman goes up against a greater challenge than giant *kaijus* or a morally compromised science team – raising a child. And not just any child, but a baby *kaiju*, born of one of his supposed enemies, Gigantron.

The baby, eventually named Emi by Professor Sato, was part of the original *Made in Japan* concept, and was designed by Shannon Tindle back in 2001. "She hasn't changed," said Tindle.

"I wanted her to have *kaiju* elements. And for a *kaiju* in the film, what was important to me was they had to look like they could be a living creature, but also that a person could fit inside a suit," Tindle said. In the original *Tokusatsu* films, all *kaiju* are played by actors inside of elaborate suits. As a result, "They're all on their hind legs. And Emi had to follow that as well. What would it be like if a toddler were in an Emi suit?"

▲ Nacho Molina expressed how Emi would be peacefully nestled inside her egg.

▶ In this Style Guide piece, Khang Le and Sunmin Inn considered how character stylization would work against backgrounds.

Tindle knew that he wanted her to have the proportions of a toddler – the oversized head and the chubby legs and arms that Tindle's daughter had. He also wanted her to be mercurial. Tindle referred to a series of three photos of his daughter, taken within seconds of each other. "She's mad, then she's crying, then she's laughing," Tindle said. There's a moment in the film where Emi goes through a similar emotional transformation, inspired by Tindle's daughter.

"What's been really incredible is when the animators came on, they were all drawing from their kids. And now everybody who sees the movie, they're like, 'That's my kid', which is one of the most rewarding things I've ever experienced... Because we were so specific in how we presented our own children, everybody feels like they have ownership," Tindle said.

When he started out thinking about Emi, Tindle figured that he could go in the lizard-monster direction or the bird-monster direction. "I'm going to go bird because I think I could do something a little cuter with her that way. She's going to hatch from an egg, so let's have the bird elements," Tindle said. He was also inspired by the

fact that baby birds look nothing like they do when they are full-grown, adult birds. "There's a huge amount of transformation. If I see a puppy, I can see the adult dog and the puppy, but a baby bird and the adult version, I wouldn't know which kind of bird they were."

Tindle had already designed Gigantron, so he knew what Emi would look like all grown up.

Emi has a distinctive pink colorization, which Tindle said, "wasn't because I was trying to ascribe to any kind of traditional or conventional gender markers." Instead, he was inspired by a little cartoon octopus character he saw in Japan that had a similar color scheme. When he first designed the character, he didn't even have a gender. "That wasn't the idea at all," Tindle said. "It was just me taking inspiration from a little vinyl toy I had."

Not that she even stays pink. In an effort to have a nonverbal character be able to clearly express emotion, it was decided Emi would change color. The rest of her characteristics would be based around things that parents deal with when raising a newborn. "But they're weaponized," Tindle said. "When she cries, it's a sonic boom,

▲ Gabriel Gomez took on the painstaking work of designing Emi's scale pattern.

▼ Shannon Tindle's early designs of Emi.

▶ Andrew Chesworth explored Emi's huge range of emotions with expression studies, informing how much ILM could expect her face to need to move.

▼ Sunmin Inn painted over ILM's first pass of Emi's final look, showing how linework and stylization details should be treated.

▶ Chesworth also created pose studies, showing Emi at her most adorable, curious, playful… and destructive.

it's a screech, it shatters glass. It was really trying to take all those things that you would experience as a parent and turn them into [actual] weapons of destruction, which is what it feels like."

Sure, she's a baby with atomic breath that would make Godzilla blanch, but isn't she cute?

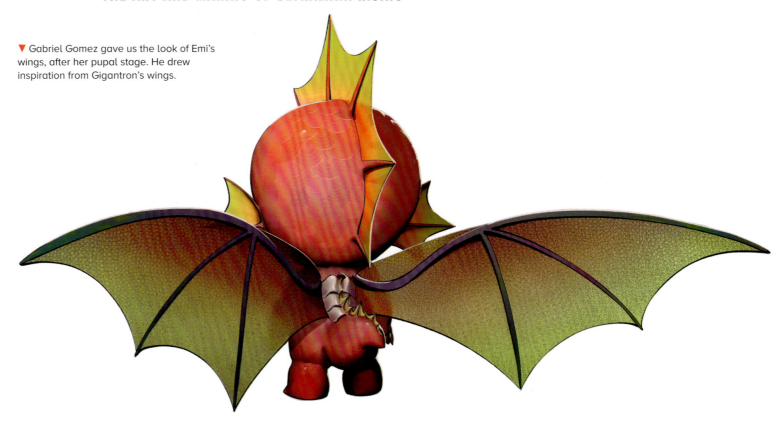

▼ Gabriel Gomez gave us the look of Emi's wings, after her pupal stage. He drew inspiration from Gigantron's wings.

▼ Ultraman's world opens up as he cradles the delicate infant *kaiju* in his hands.

▲ Nacho Molina took Gomez's grown-up Emi, and figured out how her bioluminescent glow would look in the final battle, as she tries to break through to Gigantron.

▼ Molina also explored Emi's bioluminescence for her wide range of emotions.

▶ ILM's final rendering of Emi.

THE KAIJU

Like any hero, Ultraman is only as good as his villains. And he, historically, has some of the most unforgettably monstrous foes – classic characters like Neronga and Bemular.

In *Ultraman: Rising*, he faces a new *kaiju* called Gigantron, whose offspring Ultraman raises as his own. The task of updating the older creatures and creating the new monsters fell, once again, to Shannon Tindle and Keiko Murayama.

The guiding design principle for the *kaiju*, as established by Tindle, was that they would be bipedal, so that, conceivably, a person could be inside the characters like the classic suited creatures of *Tokusatsu* cinema and television (like the original *Ultraman* series). But Tindle also wanted to make them look more naturalistic, like creatures you could actually find on this planet.

Naturalism was what Murayama was going for in her designs. While she admits that she doesn't know how many of the *kaiju* designs she did made it into the final film, she does refer to the angle that she took. "I vaguely remember when I started approaching it, I was thinking more like, 'What if they look like they were more of a real creature?'" Murayama said. "I was referencing real world creatures, adding more reality into the original *kaiju* design. But on the other hand, what Shannon really wanted was for it to look real, but also still look like there's a human in it."

"Working with an incredible artist like Keiko is a dream. She knows her stuff and is always coming up with fresh new ideas. So, while I knew the direction I wanted to go with the *kaiju*, she always inspired me to push things further," said Tindle.

And the final designs did wind up embracing both of these ideas – more realistic but still very man-in-suit-y.

"With Neronga and Bemular, I really want people to be able to look at it and go, 'Oh my god, there's Neronga! Oh my god there's Bemular!'" Tindle said. It's part of the same, visual shorthand that allows people to recognize *Ultraman: Rising*'s interpretation of Ultraman as the character that has been around for almost sixty years. And like Ultraman, over the past sixty years those characters have, in Tindle's words, "been redesigned and reinterpreted," pointing to *Shin Ultraman's* version of Neronga, which has a more exaggerated hunched posture.

For Neronga, the character has the tusks and the electrical powers. Tindle didn't use the disappearing abilities, "which is a classic power." Instead, the edict was, "Hey, it's got to be in our style, so let's match the design language that we've created for the movie," whilst still maintaining some of the elements that made the original versions of the characters so indelible.

Gigantron, who has some characteristics more closely associated with a dragon, followed

◄ Gigantron and Ultraman face off outside New Tokyo Dome.

the design edict of the original characters so well that Tsuburaya has already crafted a man-in-suit version of the character, who has made select media appearances. The spirit of *Tokusatsu* is alive and well in *Ultraman: Rising*.

While Emi is the only baby *kaiju* you see in the movie, there was an alternate ending where – spoiler alert – Ken, his dad, Gigantron, and Emi actually make it to the island, where they're greeted by other orphaned *kaiju*. There's a sequence earlier in the movie, where Dr. Onda walks through the lab and you see all the *kaiju* he's felled. This would have been the payoff for that moment.

◄ Shannon Tindle honed in on Gigantron's final design with these drawovers of her wing anatomy.

▲ Gigantron attacks Ultraman with her Chemiluminescent Blast.

◄ Sunmin Inn completed the "gigantic" task of this detailed painting depicting Gigantron's colors and stylization.

57

◀▲ Gigantron's Chemiluminescent Blast needed a fearsome appearance – Nacho Molina explored how this might look.

▲ Molina also tackled Gigantron's emotional bioluminescence as she dies, trying to protect her egg.

▼ Mecha Gigantron needed to be a terrifying opponent. Keiko Murayama provided linework designs and Gabriel Gomez painted the final look.

"We just had to make thoughtful decisions regarding budget and production, and I am actually really happy we ended the way we did, because it's the promise of what's going to be on that island rather than going there and literally seeing it," Tindle said. Ken's mom would have been there too, acting as a Jane Goodall for the baby *kaiju* – including a baby Pigmon ("one of my favorites") and a baby Red King, both of which were designed by Murayama.

Tindle is hopeful that we will see these other baby *kaiju* in future films.

BEMULAR

◄ Bemular was a late, but welcome, addition to the film; in fact becoming the first *kaiju* to appear on screen. Shannon Tindle whipped up a design quickly for ILM, and Sunmin Inn went on to provide local colors.

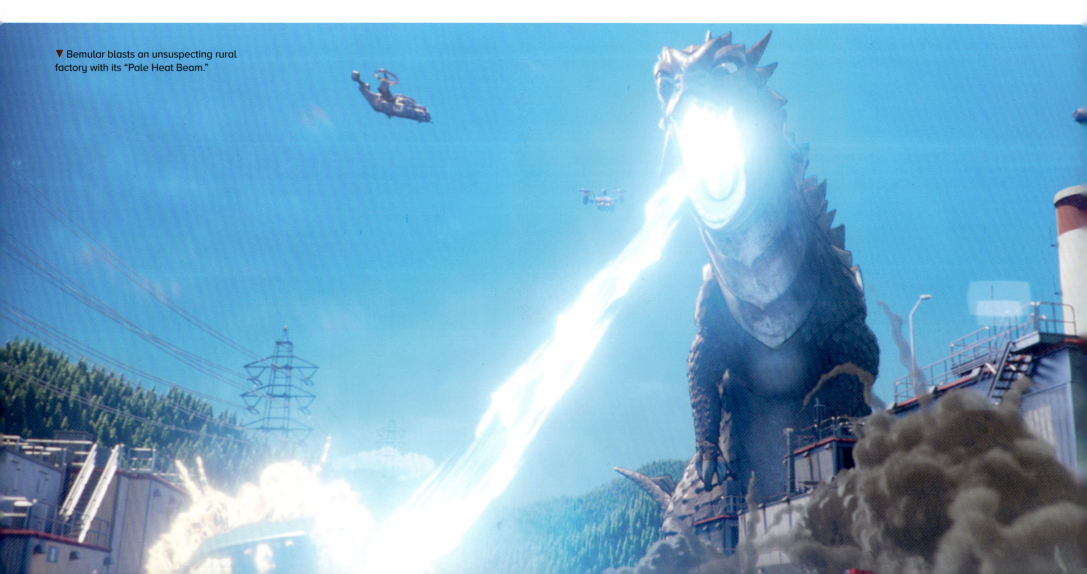

▼ Bemular blasts an unsuspecting rural factory with its "Pale Heat Beam."

▼ Bemular is Maddie Lazer's favorite *kaiju* from the *Ultraman* universe. So when the time came to finish her color and texture, Tindle asked for Inn to subtly hide Maddie's name on Bemular's belly.

STAINS TO HIDE NAME ON CHEST

▶ Bemular's final rendering by ILM.

NERONGA

▲▶ The top two images show Keiko Murayama's approved design in sketch form, and then fully rendered by ILM from the back. Undearneath, Tony Fucile sketched the formidable Neronga ready to attack, a pose which was then matched by ILM for promotional use.

▲ *Ultraman: Rising* introduced a new special power for Neronga: the "Wrecktro-Electric Ball" move. Curling up like an armadillo, Neronga rolls at the enemy at great speed. Shannon Tindle sketched how this could work with Neronga's anatomy, and ILM brought the vision to life with a bespoke asset, appropriately named "nerongaBall."

◄ Gabriel Gomez took two passes to depict the detailed color and surfacing to bring Neronga to life. First he focused on linework and texture, and then explored the full-color, also depicting Neronga's glowing horn.

63

THE HUMANS

 Ultraman: Rising is full of stuff – giant robots and alien superheroes and monster babies – that it's easy to imagine you'd lose track of the human characters in this huge, expansive sci-fi world. But that isn't so. Each of the characters is so unique and so fully fleshed out that they feel just as big and important as any *kaiju* rampaging through Tokyo.

▲ Ken nurses his post-fight injuries in an ice bath in Sequence 2500, "You Have To Raise Her, Ken."

▶ Having just lost his father and Mina, Ken charges towards a cliff's edge to rescue Emi.

KEN SATO

Ken Sato (voiced by Christopher Sean) is the main character *of Ultraman: Rising*. He's the son of Professor Sato, the original Ultraman. Ken is a star player for the Yomiuri Giants, after going to America and playing on the Los Angeles Dodgers. He also is something of a heartthrob, who starts the movie as a bit of an egomaniac but softens to become a better hero (and a better baseball player) after he becomes the ward of a young, orphaned *kaiju*.

"Ken is a superstar, so he's going to be in shape, and I wanted him to be attractive," director Shannon Tindle said. One thing that he was absolutely adamant about was Ken's hair. Tindle modeled his style on a young Toshiro Mifune, who is perhaps best known for his collaborations with Akira Kurosawa and for appearing in western films for John Frankenheimer, Steven Spielberg, and William Richert.

Looking at photos of a young Mifune, you can see the unmistakable swoop of hair he shares with Ken Sato.

Keiko Murayama worked from a sketch of Ken by Tindle. "I understood the shape 'language' he wanted for the proportions. From there I looked through all of Shannon's character designs, even from *Kubo* and everything. And then it's like, 'Okay, how does he like to describe a knee? How does he like to describe a joint?' All that stuff. I studied it," Murayama said. "And then I took all that and created that Ken shape."

Murayama said that Tindle had a very clear vision of who Ken was. When they first set out to design him, they didn't want to capture a person who looks *too* tough. Murayama consulted the 1947 film *Snow Trail*, which has a screenplay by Kurosawa and starred a young Toshiro

Dome shape cover /digital display

versace
Black/Gold Greek Key Bracelet
$395

versace
Gold Dogtag Necklace
$425

AGED BASEBALL GLOVE LEATHER
KNIT COLLAR LINING
"ZIP-A-TONE" PERFORATED UPPER
CANVAS UPPER
BLACK PATENT LEATHER TOE BOX

LEATHER
RUBBER MID SOLE

MAP OF TOKYO PRINT BEHIND OUTSOLE
TRANSLUCENT GUM RUBBER

KEN SHOES / OVI- "TOKYO"
CLASSIC MID

▲ It was important that Ken's swagger extended past his performance, and into his entire style. Keiko Murayama worked in all the little fashion details, except for two assists; the Omega Speedmaster watch was Shannon Tindle's suggestion, as it was used by the Science Team in *Ultraman* canon, and Ken's shoes were designed by the team's on-staff sneakerhead, Ovi Nedelcu.

▶ Ken rendered in all his glory by ILM.

▶ Mayumi Nose made sure Ken looked his best for his second interview with Ami, adjusting his costume to be a bit less casual.

▶ To explore Ken's facial expressions, the team tapped celebrated animator and character designer, Rune Bennicke.

▼ In assets aptly named "kenInjured", Keiko Murayama created designs showing that being a superhero and baseball superstar can be painful.

Mifune. "The whole movie he has this one strand of hair," said Murayama. "That's where [Ken's] strand of hair comes from." Murayama wondered what would happen if the young Toshiro Mifune and the anime character Gatchaman had a baby together. (The Gatchaman character was introduced in 1972 and was known to western audiences from the English adaptation *Battle of the Planets,* released in 1978.) Ken is the answer to that hypothetical union.

Mayumi Nose, one of the character designers, grew up in Hawaii, with a Japanese broadcast channel that would not only air *Ultraman* but also the early work of Toshiro Mifune. She didn't recognize the name, but when Tindle brought him up as a source of inspiration, Nose looked him up and discovered that – wait a minute! – this was the same actor whom she had seen on the Japanese broadcast channel when she was growing up. In terms of adapting Mifune's characteristics to Ken, Nose said, "He is a difficult one because he is so charismatic on the screen and just very... your eyes kind of want to follow him."

There was also the question of what Ken would wear, with Murayama taking down notes – his T-shirt would probably be from Calvin Klein ($500), with a necklace maybe from Versace ($12,000), and perhaps he even wears pieces by the accomplished jewelry designer (and production supervisor, story and script) Makiko Wakita. "I have to know all that because the items described who he is, too," Murayama said.

When Tindle showed the character's design to the team's cultural consultant Mayumi Yoshida, her response was, "He's the kind of dude that I know and I would not mess with. I wouldn't get within a mile of that dude. He's trouble." "And I was like, 'Good, great, awesome, so mission accomplished,'" said Tindle.

▼▶ Before the Giants and Dodgers, Ken Sato played for the fictional Los Feliz Tigres (a nod to Emiko Sato's favorite team, the Hanshin Tigers). This young version of Ken was designed by Keiko Murayama, and packeted and turned by Mayumi Nose.

▼ Tindle and Aoshima asked Murayama to be as true to real life as possible when designing Ken's baseball uniforms. This involved extensive research into materials, brands, and styles. Though you mostly see Ken as a Giant, eagle-eyed viewers will notice his Dodger's uniform on a magazine cover.

technical/sport mesh

leather & felt

See: Ovi "Dodgers" cleats file

embroidered team hat

Elastic sport belt

◀ No one was better equipped to depict the full range of what Ken Sato could experience as a professional baseball player than Tony Fucile. He explored moments of success and failure on the field.

▶ *Ultraman: Rising* asked a lot of the animators, including animating thrilling baseball moments, like a third pitch. Fucile leant a hand by sketching pitching form for the team.

▼ Fucile dreamed up Sato's pre-bat ritual.

PROFESSOR SATO

Professor Sato (voiced by Gedde Watanabe) is Ken's dad. He was the previous Ultraman and, in a bit of lore building that is visible just beneath the surface, may not be as human as his son. Still, in *Ultraman: Rising* he is the father who was never around, someone that Ken both admires and resents. And it's their relationship, which at the beginning of the movie is so strained but eventually is healed by the conclusion, that forms the emotional bedrock of the movie.

Tindle admits that when they were first working on Ken's dad, the early designs were "a little Hayao Miyazaki." "But then when we started to get into it for this film, I wanted him to have a very vulnerable face." Tindle turned to Takashi Shimura, another legendary Japanese actor (and Kurosawa collaborator) for inspiration. "He's one of my favorite actors of all time," Tindle said.

He was also inspired by Brad Bird's *The Incredibles*. "What I always loved about the design is the proportions were really broad, with huge contrasts in shape and size," Tindle said. "It works." Tindle pointed to Bob's diminutive boss (voiced by Wallace Shawn) or Edna Mode (voiced by Bird), the designer of the superheroes' costumes.

"Ken's dad, I wanted to be like, *whoa*. He kind of shrank as he got older. I thought that contrasted well," Tindle said. "And Ken's quite tall, like his mom. What do they look like next to one another? That's interesting."

Murayama said that, when she first boarded the project, Professor Sato's backstory was "still ambiguous." Instead, Tindle provided *Ikiru* (1952) as a reference, which is what she went with. She remembers Tindle pointing her towards "that kind of sadness that Takashi Shimura has in that movie." "I watched it and I was like, 'Okay, just trying to capture the essence of someone very sad, but trying to do something good, do something right,'" Murayama said. "A sad man with a really heavy burden."

And a giant mustache.

"Giant mustache is a must," Murayama said. Yes, it is. There's a reason that the mustache returns when he becomes Ultradad at the very end of the movie. It's just that good.

▲ Gabriel Gomez handled Professor Sato's color and texture paint, which was used by ILM to achieve his final look.

◄ We first meet Professor Sato as a young man in Ken's childhood apartment, nestled in Shinagawa. Tindle wanted him to look strong, but in an understated way. Murayama understood the assignment.

▼ Professor Sato's expression studies were completed by another animation icon – Sandro Cleuzo. If you look closely, you'll notice these were done the old-fashioned way, with pencil on animation paper, scanned for digital delivery to ILM.

▼ Again, Murayama needed to injure a character — and this time, a feeble old man! All joking aside, the design needed to break hearts as Professor Sato is in his life support chamber, just before the final battle. Murayama kept his injuries subtle.

▲ Michel Guillemain took a single concept from Shannon Tindle, and created an art model of Professor Sato (above left). That model was passed to Gabriel Gomez, who painted over it (above right). Whilst much remained the same, the toy featured in his satchel still needed to be developed into "Ollie."

▶ Tindle's original concept of Professor Sato.

EMIKO SATO

▶ An emotional core of the film, it was important for Emiko's design to capture her multifaceted personality. She needed to be strong and tough, but also Ken's biggest fan. Keiko Murayama was tasked with designing her.

▼ You can glimpse behind the scenes into how Tindle collaborated with ILM - his red-line draw-overs helped riggers and animators refine their tools and posing to give Emiko the best performance possible.

don't be afraid to cheat irises and pupils larger

maintain graphic edges

▲ Murayama had to design Emiko as the years passed. Here, she sketched how Emiko would have looked, just before she went missing.

▶ Nacho Molina painted the older Emiko's color and surfacing treatment. Unfortunately, switching to a new short hairdo had a hefty price tag attached to it. In the film, you instrad see Emiko with grey hair pulled back into a bun, which was lower complexity and more affordable, but just as effective.

◀ Sunmin Inn's color key, describing the lighting setup in Sequence 0100, "Where's Daddy," shot 0070.

AMI WAKITA

Ami (voiced by Julia Harriman) is a sports reporter who challenges Ken and then winds up bonding with him because she, too, is a single parent. (Although her child doesn't have laser-breath and we're fairly certain cannot level an entire city block.) She must be tough and tenacious, but also sensitive and fair.

Tindle said that he wanted to play Ken and Ami's relationship as purely a friendship, nothing else. "I always wanted two adult people who could be in a room together in a film and not have to have any romantic connection," Tindle said. "I think there is a connection there. I think when Ken starts to open up, she admires him, but I was very adamant that it has to be platonic."

During the process of making the movie, the team learned that there weren't a lot of women sports journalists in Japan. They spoke with one female sports journalist who told them that there's this horrible assumption that if one of the female journalists is interviewing one of the male athletes, there's a relationship there. They put a reference to this into the movie, where a character makes a comment about Ami having a "one-on-one with Ken Sato" and she shoots back angrily. "I just wanted to have a little bit of that in there to show what Ami has to deal with in the world that she's chosen to be in," Tindle said.

Ami's designs were once again inspired by Leiji Matsumoto and the way he proportioned characters. And they also found inspiration much

▼ Sandro Cleuzo also leant his pencil to Ami, exploring a diverse set of expressions that would bring the determined journalist and loving mother to life.

◀ Ami in the film's final scene.

▶ Mayumi Nose and Keiko Murayama collaborated on Ami, with Nose leading early costume explorations. Ultimately, Nose landed on a suit that Ami would wear to the press conference and her first interview with Ken Sato. The only difference between these sketches and the final version? Ami would be wearing a subtly tiger-striped shirt, alluding to the fact that she, like Ken's mother, supports the Hanshin Tigers.

PRESS
PASS ID

氏名 脇田 有実
Ami Wakita

YOMIURI SHINBUN

◀ Every detail of an animated film needs to be designed, down to the press badge Ami wears. This element was designed by Minako Tomigahara.

▲ Ami chats on the phone with Ken, surrounded by "Chiho's artwork," which in fact include sketches from production supervisor Jen MacVittie's son. This shot was inspired by one of Tindle's favorite films, *Kramer vs. Kramer*.

closer to home, again in Makiko Wakita. Tindle had already given Ami Makiko's surname, so one day Murayama had an idea. "I was sketching Makiko over Zoom, and then I was like, 'You know what? This is nice.' So I shared it," Murayama said. "And then from there, they said, 'Okay, Makiko is our Ami, it is decided.'"

Nose came on after the design had been finalized by Murayama. "When I came in, it was really just to kind of sell the character a little bit more and then explore the different versions of her you see in the film," Nose said. "I worked a lot with her costuming in specific parts.

When she's doing the interview with Ken in the very beginning, they wanted her to feel a certain way, and they wanted to make sure that she had some kind of call out to a tiger."

Tindle said it was important that she be a fan of the Hanshin Tigers, *not* the Giants. "How do we state it without saying it? Well, she wears black and gold," Tindle said. He points to her wearing an embossed tiger print on her shirt. But Tindle fought for costume changes too. It's an expensive proposition in animation, but one that he advocated for. "Let's have a wardrobe that we

▲▶ Mayumi Nose explored other outfit options for Ami's second interview with Ken, ultimately landing upon the stylish get up shown here.

▶ Ami faces off against an obnoxious fellow reporter named "Kubo," who looks startlingly similar to the film's co-director, John Aoshima.

can swap out so it doesn't look like they're wearing the same clothes every day," he told the team. These sartorial changes were applied across the rest of the cast, and helped showcase their personalities and emotional growth.

In the sequence where Ken and Ami are in the restaurant, Nose said, "They wanted her to feel like, 'Oh, she is really coming after him a little bit.' And so going from that and then progressing through the movie and kind of seeing a more... that parenting-is-hard-on-a-single-mom side of her, that really changed her wardrobe and changed her feel as a character."

▼ Ami flashes a "Spacium Beam" at Chiho while she's on the phone with Ken.

▶ Sequence 0500, "The Interview," was one of the first sequences to pass through ILM's hands for style, lighting, and color, and established how the studio would treat quiet, character-driven scenes. Nacho Molina painted this vital color key for shot 0250.

CHIHO

▲▼ Designing the ultimate "UltraFan" was an exciting task for Keiko Murayama and Mayumi Nose. Mayumi turned Chiho for modelers, while Keiko worked with ILM to refine the design.

► Chiho strikes an iconic Ultraman pose.

▲ What would Chiho wear around the house? Ultra PJs, of course! Murayama sketched the adorable outfit.

▲ Chiho's shoes feature the Ultra-fan-favorite *kaiju* Pigmon.

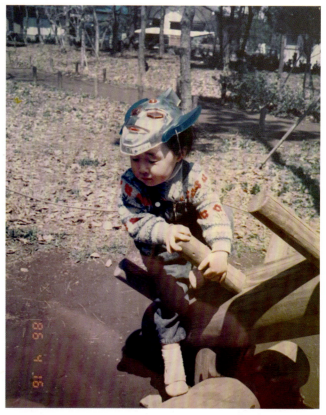

▲ Keiko found a childhood photo of herself, with a sweep of unruly hair, and an Ultraman mask pulled to the side. It was a detail that Tindle was so fond of, he wanted it in the film. Murayama was happy to oblige, and drew up this updated design.

◄ Chiho busts through the door at a fancy restaurant, surprising Ami and Ken.

◄ Murayama's design, based on her childhood photo.

81

DR. ONDA

Ostensibly the villain of *Ultraman: Rising*, Dr. Onda (voiced by Keone Young) runs the movie's science team, the KDF (Kaiju Defense Force), and is hellbent on systematically exterminating the *kaiju* after an attack led to the death of his family. His backstory gives him sympathy, which even influenced his costume; the fabric inside of his jacket, inspired by the Japanese technique *boro*, in which old cloth is used to create something new. Keiko Murayama designed a pattern for Onda's daughter's pajamas and Onda lines the robe with this fabric as a way of remembering her.

It is his unwillingness to let any of the *kaiju* go which makes him a bad guy. This is especially true after he murders Gigantron, Emi's mom (and wants to go after Emi, too). This guy is unstoppable.

"With Dr. Onda, it was about wanting him to have a clean silhouette, wanting him to be a bit angular, wanting him to represent a little bit more of a military background with the crew cut, but also he's a civilian now, so let's have his default costume be something that draws from tradition," Tindle said. "That he's a conservative guy, that he's a traditional guy, and that he would wear something like that."

"I specifically wanted there to be this element of an older, maybe more traditional costuming, but mixed with this scientific, modernist kind of a man who's stuck in the past a little bit," Nose said.

▼ Dr. Onda's face needed to convey the inner life of a hardened leader, driven by grief. Sandro Cleuzo drew a range of expressions for ILM to use as they developed Dr. Onda's rig and performance.

▲ Gabriel Gomez again leant his painting skills to the color and surfacing studies of Dr. Onda.

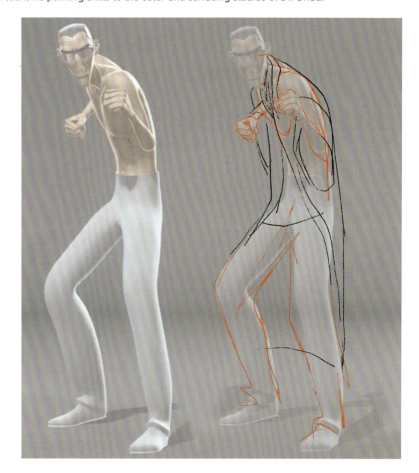

▼ An early design of Dr. Onda by Shannon Tindle.

◄ Tony Fucile explored how Dr. Onda's robe would drape over his poses, which informed the cloth development team's work.

▲ Marcos Mateu-Mestre took an initial linework pass over Dr. Onda's model, to better define the shaping and crease patterns of his costume.

▶ Gomez built on that linework to deliver this full-body color and surfacing study.

Tindle and Nose went back and forth on what he would look like and what he would wear. But it helped that Tindle had a very clear idea of who Dr. Onda would be.

"Shannon had something very specific in mind, which is great because the hardest thing, I think, sometimes as a character designer in the beginning of production, is not knowing who the character is. Story has to dictate that, but sometimes the story is in flux, or they're not a hundred percent sold on who that person is. But luckily, that wasn't the case for Onda," Nose said. "And because of that, it was really easy to just jump in quickly with a bunch of different directions and a bunch of different stuff."

While Tindle loved and supported Nose's idea of a more traditional ensemble for Onda, he was quick to remind the team that, "When he's on a mission, he's in a KDF uniform like everybody else. And that he would still cut a striking silhouette."

Another element of the design was that Onda was always hiding his eyes. This served as another nod to *Neon Genesis Evangelion* but was also very intentional for his character. Tindle said that you only see his eyes a few times – when he's watching the home videos of his family ("Because he's vulnerable there, but he immediately puts them on when Captain Aoshima comes in the room") and when he says he's prepared to die ("He's opening himself up to Aoshima to say it"). "That was the philosophy. And you can get just a lot of cool things with reflections," Tindle said. "They do it in *anime* all the time."

Nose said that not showing his eyes was "one of the tentpoles of his character that I could not change." "He's the type of character where you don't know a whole lot about him in the beginning, and then you kind of get a little bit more of his past and you start to understand his motivations a little bit more as the story progresses," Nose said.

And the great thing about Onda is that, even after you know more about him, he's still just as scary.

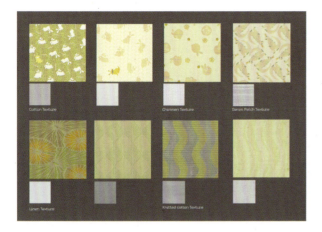

▶ A telling character detail is included in the lining of Dr. Onda's robe – a *boro* design, created from his daughter's outfit in the final video of her alive. By lining his robe with the memory of his daughter, his singularity of purpose is always conveyed. The concept itself was suggested by Keiko Murayama and Minako Tomigahara, and the *boro* design was painstakingly conceived by the latter.

▲ Many team members contributed to designing the KDF logo — there was even an open call for designs! Ultimately, the final logos were provided by Tomigahara. The logo on the left is as it would appear on KDF employee's lapels. The logo on the right would sit on their right arms, with the number of stripes indicating their rank. Dr. Onda's logo had four orange stripes.

▼ A younger Dr. Onda appears in the film in a flashback. Murayama was tasked with aging him down. Ultimately, these designs were adjusted to have him wear his KDF uniform.

▶ Mayumi Nose designed Dr. Onda's KDF uniform, which went on to be the basis for the rest of the KDF.

▲ As you will see in future pages, Ryo Yambe was hugely involved with designing the Mech Dr. Onda operates in the final battle. Here, he even broke down the graphics that appeared on Dr. Onda's heads up display.

▼ A heartbreaking color key of Dr. Onda's daughter's last moments alive, painted by Marion Louw for Sequence 3600, "Home Videos/ Heartbeat."

▲ Marion Louw also painted this color key of Captain Aoshima entering Dr. Onda's office in the same sequence.

▲ A tone key of Dr. Onda walking down the KDF Catwalk, painted by Marcos Mateu-Mestre.

◀ Louw's final color key for the sequence.

▲ In addition to the reporter Kubo, Captain Aoshima's design was based on the film's co-director, John Aoshima. Mayumi Nose was responsible for this adaptation.

▼ Dr. Onda informs Captain Aoshima that the KDF needs to abandon ship.

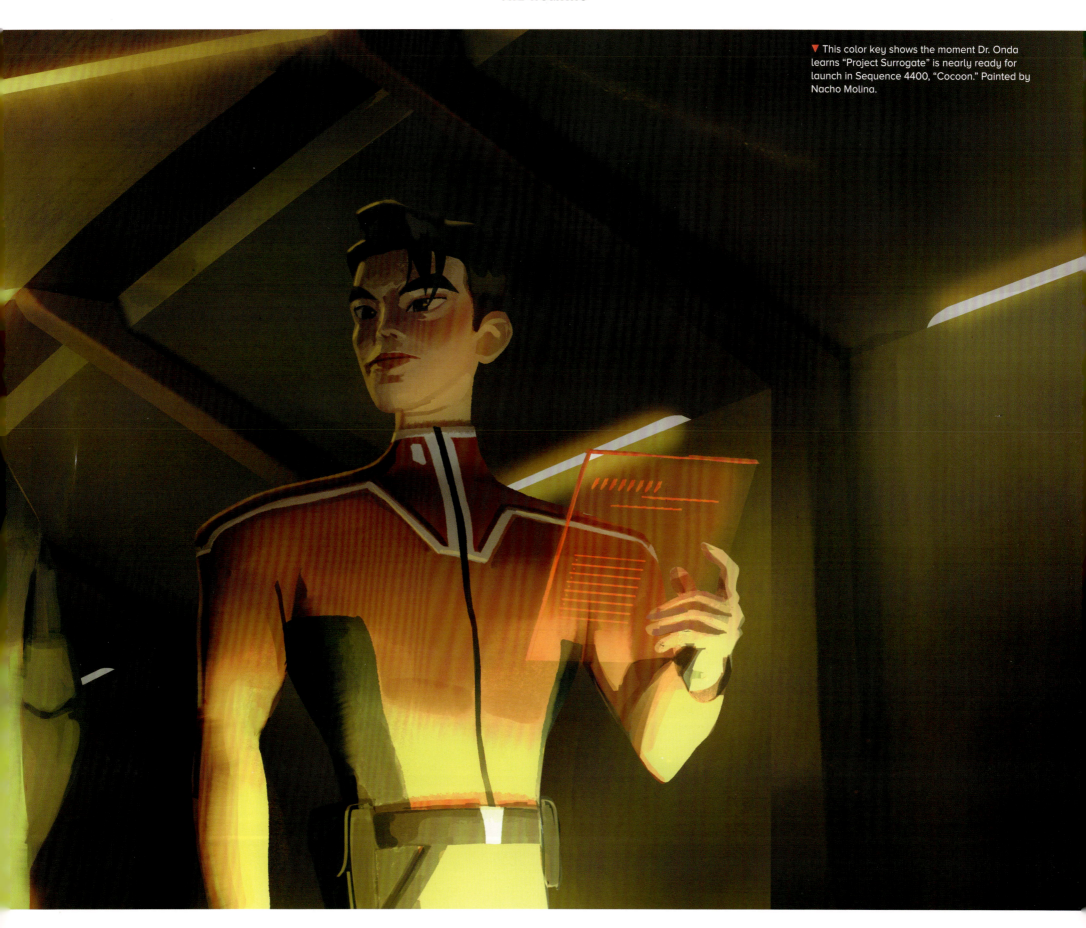

▼ This color key shows the moment Dr. Onda learns "Project Surrogate" is nearly ready for launch in Sequence 4400, "Cocoon." Painted by Nacho Molina.

TOPS FROM CROWS

plaid pattern OK

pants update

◀▼ This spread: Populating Tokyo with a diverse range of characters was a monumental task, led by Keiko Murayama and Mayumi Nose. Eventually, a system of crowds based on interchangeable heads, hair, bodies, and costumes allowed ILM to make each neighborhood feel properly alive.

▼ Marion Louw's color key for Sequence 3350, "Baby's Night Out," in which an unsuspecting crowd of bookstore customers come face to face with a *kaiju*.

▲ In a world with frequent *kaiju* attacks, it stands to reason that Tokyo will need crowd security personnel and police officers, in addition to the KDF. Keiko Murayama designed these characters, as well as a concessions seller at New Tokyo Dome.

▼ Murayama threw in some unique character costumes to round out Tokyo's crowds.

▼ Ami, Chiho, and Oba-chan flee Emi.

BASEBALL

In *Ultraman: Rising*, Ken isn't just the new Ultraman. And he's not just the reluctant father to an orphaned baby *kaiju*. He's also a world-class athlete, a blockbuster baseball player who left Japan as a child, and wound up playing for the Los Angeles Dodgers (sound familiar?) before returning back to Japan. Sure, he had to return to the family business of regularly saving the world. But he also joined Tokyo's team, becoming a standout player for the Yomiuri Giants.

Tindle was inspired by films where "you take a character who seems to, from the outside perspective, have it all, but their life is actually quite restrictive." Take, for example, *The King's Speech* where, "he's the literal king but he can't speak in front of people."

"I wanted there to be a thing where Ken went in a totally different direction from what his dad wanted him to do," Tindle said. "Playing baseball together is something we associate with fathers and sons. Those moments they shared when Ken was younger were his motivation for becoming a baseball player. and for Ken saying, 'I wanted to be a baseball player because, it made you smile. That's why I did it.'"

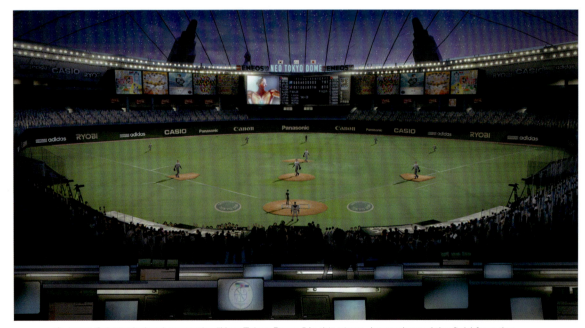

▲ Jason Scheier helped create the "New Tokyo Dome." In this piece, Jason showed the field from the perspective of the press box.

▶ Ken teaches Emi how to hold a baseball bat.

Tindle also admits that the idea of Ken being a baseball player was "sexy." On previous *Ultraman* projects, they had never had him be a very public figure. Usually, he's a somewhat anonymous member of the science team, which adds an element of mystery but not much else. Tindle wanted his Ultraman to be "outside that world." "When he's asked to take on the mantle of Ultraman, it's a huge sacrifice," Tindle said.

Ken always had that swagger, something that co-director John Aoshima said was unusual for Japanese players. Makiko Wakita thought that perhaps a period of Ken's life in America would explain it. That suggestion only added to the character.

"It's very common for Japanese players to be grabbed from their home team and pulled over for an American team. But what does it feel like if you have to come back, and you come back to a world that doesn't feel like your home anymore," Tindle said. "You're not part of [American culture]. You worked really hard to try and be a part of it. Now

you've got to give that up and you've got to come back. And when you come back [to Japan], they don't see that you're worthy either. These ideas were inspired by Makiko and John's personal experiences."

As part of his research, Tindle consulted *You Gotta Have Wa* by Robert Whiting, a book about American baseball players who go over to Japan. The book explains the intimidation techniques Japanese players use on American players. They will oftentimes walk American players just for the intimidation factor, meaning let them walk to first base instead of letting them hit the ball or strike out. They don't care that they're making the game less exciting. "They want to get in your head, so they will walk you every time," Tindle said. Because Japanese fields aren't as deep, American sluggers often have no problem hitting the ball out of the park. But the opposite team will have no problem walking the American player. This played into the themes of *Ultraman: Rising*.

▲ AJ Jothikumar storyboarded Ken's first game as a Giant in Sequence 1300, "Yomiuri Giants vs Yakult Swallows."

▼ Earlier in the film, Ovi Nedelcu storyboarded Ken in his element – at bat – in Sequence 0200, "Meet Ken Sato."

As to how to portray all of that baseball in the movie, well that proved considerably trickier.

"We had baseball action, but the storyboard artists didn't all necessarily totally know baseball," editor Bret Marnell said. To help the artists, Marnell would "steal a piece of baseball action," and then the artists would board that.

Once animation started coming in, the team relied on another baseball fanatic to hone and refine the movements, as well as offer other helpful, baseball-related tips: Tony Fucile, head of character animation. Fucile is a legendary animator who started at Disney in the 1980s and contributed to everything from *The Little Mermaid*, to *Who Framed Roger Rabbit*, to *The Nightmare Before Christmas*. Later he would work on projects like *The Iron Giant*, *The Incredibles*, and *Soul*. Like we said: a true legend.

▲ Sunmin Inn painted this early concept of an impact frame, which was later realized by ILM, in Sequence 1300.

▼ Color key by Yoriko Ito for Sequence 1300.

Fucile played in high school and eventually in college, "and then got hurt and it's a long story." His father was also a professional baseball player, until he got drafted into the army. "Baseball is kind of in our family genes," Fucile said. He says that he is still obsessed, even though he can't play anymore. "I still get really into the mechanics of stuff and how that was evolving in terms of hitting. I'm not that knowledgeable about pitching, but I know a little bit about it, but mostly hitting and fielding, hitting especially," Fucile said.

Fucile was the one who figured out how Ken was going to swing the bat, even what his approach would be when he was setting up on the plate. "Every hitter has a series of rituals they use to get into the mindset and I thought, 'This is really amazing,'" Fucile said. He shot reference with his son, who is a really good baseball player. And Fucile admitted that he had a lot of fun when Ken was having a really hard time. He remembered a moment when Jose Canseco had a ball bounce off his head, so Fucile incorporated that for a similar moment in *Ultraman: Rising*. There's also a moment of Ken crawling that was borrowed from real life. "That's something I think Keith Hernandez did once. It was just so fun to get that stuff in there and hopefully baseball fans will notice," Fucile said. They certainly will now.

Fucile also mentored the international animation teams, who knew next to nothing about the game, in the ways of baseball. "It was fun to get in there talking about how a curve ball is different, how pitchers hold the ball and how that affects the spin and that kind of stuff," Fucile said. "It's really, really hard to animate baseball convincingly. So many things have to go right for it to feel real. Like even in the most cartoony baseball animation, it's tricky. It was a challenge to get the pitching looking good and all that other stuff."

It was Fucile who would take animation and do his famous "draw-overs," where he would sketch over drawings or work-in-progress animation, suggesting ways to improve the movement of the action in ways that would not only strengthen Ken's character, but make the baseball action truer to life and easier to understand. This is especially helpful if you don't know much about how baseball is played. Fucile's knowledge of the sport turned out to be incredibly helpful.

"Having Tony come in and just go through a load of reference of professional baseball players to really analyze a pitch, a swing, how do each of the pitcher styles vary? Sometimes we were having to animate in a montage sequence where maybe you'd have three pitchers pitching one shot after another and they all had to look different and they all had to have their own feel. And this was something where we needed the authenticity of somebody who really knew what they were talking about with baseball. And Tony was great," said Hayden Jones, visual effects supervisor. "Not only

► As it turns out, there are very few things cuter than a baby *kaiju* playing baseball.

▼ Baseball isn't always fun and games. In this color key for Sequence 2650, "Shimura Is Pissed," Ken sits, demoralized, in the clubhouse. This particular color key was a collaborative effort between Jason Scheier and Sunmin Inn.

◀ In this color key by Marion Louw for Sequence 0800, "At Home With Ken," Ken watches old footage of his Little League win, with Emiko cheering him on.

▲ Color keys by Sunmin Inn for Sequence 3000, "Baby Plays Ball."

▲ Marcos Mateu-Mestre created this tone key of Ken and Shimura facing off in Sequence 1300.

▼ The top left storyboard shows Shimura's initial skepticism of Ken, as drawn by Jihyun Park. The next three show Ken gradually winning the trust of his team, and were storyboarded by John Aoshima.

▶ Mateu-Mestre's color key for Sequence 2300, "Slobber."

did he have the most amazing animation experience, he also had a great eye for baseball, which really was so helpful with *Ultraman*. And then Tony saw the project all the way through. He worked very, very closely with Matt Vig, who was the ILM animation supervisor. And what would happen is Matt would guide the ILM animation teams and Tony would just come in with draw-overs, [and] pushing silhouettes. Even though it's a 3D model and it changes with perspective, we were still trying our best to keep some of the sensibility that you bring as a 2D animation to the 3D world."

In other words, Fucile helped the animators knock it out of the park. No walk-offs here.

▶ Keiko Murayama designed Shimura.

THE LOOK OF THE WORLD

The team behind *Ultraman: Rising* had a tricky task when designing its world. How do you maintain, or at the very least acknowledge, the look of a property that has existed for nearly sixty years, while bringing something fresh and new to the table – not only to *Ultraman* but also to animation?

"I always knew I wanted it to be stylized. I always knew I wanted to draw from anime and manga," said Tindle. Early references he would bring up included Steve Oliff's color for the international version of Katsuhiro Otomo's seminal *Akira*. At the time, there was fear that the comic book, being reprinted by Marvel in America, wouldn't attract readers in the United States if it retained its black-and-white artwork. Otomo worked on a color guide with Oliff but past issue six, Oliff just took over.

"What I love about that color, is [that] it's emotional. It doesn't follow logic in comics. It's just if a character walks into a yellow light, they become entirely yellow," Tindle said. "I think we could push it a little bit more, but I wanted to have those instances. And I always knew if we went stylized, we were going to be compared to *Spider-Verse* no matter what, just because they did the thing that we were all wanting to do for years."

▶ Ryo Yambe (design and color) and Marcos Mateu-Mestre (linework) collaborated to bring this piece of a vis dev depicting Ultraman chasing Emi through Meguro to life.

Tindle said that *Spider-Man: Into the Spider-Verse* (and its equally impressive sequel *Spider-Man: Across the Spider-Verse*) "opened doors for everybody else to be able to explore style in a different way."

The task of conjuring this world fell to first-time production designer Marcos Mateu-Mestre and first-time art director Sunmin Inn, overseen by production supervisor, art, Jennifer MacVittie.

MacVittie knew nothing of Ultraman before starting on the movie. But luckily, she wasn't starting from square one, since the art department had access to the art from the Sony project that would eventually become *Ultraman: Rising, Made in Japan*.

"*Ultraman* is a world that obviously needed to be stylized and we needed to bring our own take," said Mateu-Mestre. "It was an existing character and also a lot of the environments are obviously fantastic, but also there's a lot of it which is Tokyo. And so that's anchored already as well." Mateu-Mestre said that there were "two sides" to the production design – one is pre-established and the other is fantasy. There's the "spectacular" buildings and skyscrapers of the city alongside the "scale of the character." "There's this duality to it, which I think is fascinating," Mateu-Mestre said.

◄ Once again, Ryo Yambe was integral to bringing the neighborhood surrounding Tokyo Tower to life. He sketched over a previs build to show ILM the adjustments they should make in modeling and matte painting.

OUTLINE RULES:
IF THERE IS A SINGLE TREE, IT WILL HAVE AN OUTLINE. IF IT'S A GROUP OF TREES, THEN THEY WILL HAVE AN EXTERIOR OUTLINE.

FULL GINKGO FOLIAGE AND VIBRANT COLOR ON LIGHT SIDE.

FULL GINKGO FOLIAGE AND VIBRANT COLOR ON LIGHT SIDE.

ONLY A FEW BURNED GINKGO LEAVES REMAIN.

PLEASE ADD RIM LIGHTING TO EMPHASIZE THE HIGH CONTRAST BETWEEN VALUES FROM LIGHT TO DARK.

GROUP LIGHT AND SHADOW SIDE, CREATING HIGHER CONTRAST.

▲▼ Justina Hnatowicz generated the previs model for the area surrounding Tokyo Dome. And below, Paige Woodward painted the final stylized look of the trees.

ADD TINY MARKS TO GROUP SHADOW SHAPES TOGETHER.

PLEASE USE BRUSH "DENSEST HASH SHADOW ANGLE."

PLEASE ADD RIM LIGHTING TO EMPHASIZE THE HIGH CONTRAST BETWEEN VALUES FROM LIGHT TO DARK.

PLEASE USE BRUSH "DENSEST HASH SHADOW ANGLE."

PLEASE USE BRUSH "SOFT HASH DENSER CROSSED DARK."

ADD HASH MARKS, REPRESENTING BURNS AND DE

ALLOW THE TREE TRUNKS TO FALL INTO SHADOW, HIGHLIGHTING THE HIGH CONTRAST ON THE FOLIAGE.

THERE SHOULD ALWAYS BE A HIGH CONTRAST FROM LIGHT TO DARK SIDE ON THE TREE. CREATING A VERY GRAPHIC QUALITY AND READ. LARGE GROUPS OF SHADOW BOOKING IS KEY!

REGULAR TREE

BURNED TRE

▼ Ryo Yambe was instrumental in making each neighborhood feel distinct. Here is one of Ryo Yambe's concepts for Roppongi, the neighborhood in which Ultraman battles Neronga.

▲ Here, Yambe explored Akihabara.

▼ Marcos Mateu-Mestre and Yoriko Ito collaborated on this style piece for a street in Daikanyama.

▼ Yambe painted this concept of the area where Ultraman and Gigantron would face off outside of Tokyo Dome.

Inn describes the entire movie as "a big growth experience." While she said that Mateu-Mestre was more on design, she was in charge of "communicating with ILM" and what she describes as "style stuff." She also helped with lighting and color. MacVittie on the other hand, was "responsible for managing the art department schedule and the art department tea."

Like so many other people in the *Ultraman: Rising* world, Inn's appointment happened because she bumped into Tindle at Netflix (she was working on *The Magician's Elephant* at the time). He needed some pitch images and she told him that she doesn't draw superheroes. Or cities. He told her not to worry about it.

"They were open to this new thing that I was doing," Inn said. They were interested in her pushing a certain kind of look. Inn said that Tindle was decisive, which made the process go by very fast.

Mateu-Mestre said that his and Tindle's design sensibilities were very much in sync, which helped the process. "His style and mine, obviously we have our standardization type differences and peculiarities to each one of our works. But when it comes to filmmaking and the visual storytelling language, we're very much aligned," Mateu-Mestre said. "And so from this point of view and many others, it was not a painful process at all."

MacVittie agreed that the art department was largely ego-free, which speaks to the kind of collaborative and communicative environment that the whole movie enjoyed. If somebody worked on a design, but somebody else on the team was a stronger painter,

then that person would jump in. "Multiple hands touched pieces of art," MacVittie said. There was never the sensation that people were stepping on each other's toes. Instead, the art department tried to play to everyone's specific strengths. Sometimes, the artists' ideas could influence elements of the stories. "The filmmakers were always open to taking the ideas and running with them if they felt like they would make the movie better," MacVittie said.

Much of the design process was guided by Japanese culture, which they were quick to refer to at every juncture. Even when things were super stylized, they were from an informed point-of-view. "Once you know what the reality is, then you can stylize that. How far you can go from it if you need to, or if you think you need to, without stretching it too much, or being disrespectful to the culture, or coming up with things that don't really gel with the real thing," Mateu-Mestre said.

Makiko Wakita, production supervisor for story and script, was a part of the consortium of artists who would advise the filmmakers on the cultural aspects of *Ultraman: Rising*. They would "go through any new materials and make sure that there's no misinterpretation of culture." This could include everything from mannerisms of characters, to colors in parts of the city that didn't make sense, to the spelling and size of certain signage. "Sometimes when things are given to a foreign artist, you just kind of throw assets in and what they think it's Japanese, and sometimes it's misused or the proportions are a little different," Wakita said. Undoubtedly, the cultural committee helped to guide the look of the film in the right direction.

▼ Ryo Yambe designed the exterior of Oba-Chan's apartment in Akihabara.

◀ Yambe and Yoriko Ito collaborated to design the interior of the bookstore, which was inspired by Tsutaya Books.

▲ Here, Yambe sketched the street area in Daikanyama where Emi initially lands, after her gigantic jump away from Ken's house.

▶ Yambe and Gabriel Gomez collaborated on this concept of Emi lost in Daikanyama.

▼ For this concept in Daikanyama, Yambe collaborated with Cathleen MacAllister.

◀ Ryo Yambe painted this early aerial concept shot of Akihabara, looking down at the Mos Burger that Neronga smashes Ultraman into.

▲ In order to truly bring Akihabra to life, though, Yambe needed to create a ton of of signage. In the upper image, he placed signage on buildings. Below, he laid out flat graphics for ILM to use. This is a small portion of the signage that Yambe created for the neighborhood.

Mateu-Mestre, who thinks he saw some of the *Ultraman* series when he was a child in Spain, pointed to the different neighborhoods of Tokyo where the action takes place, which have different flavors. The team wanted to be respectful, to capture the essence of those areas with fidelity, but also to push them, especially in terms of lighting, into a more stylized place.

"Marcos is a brilliant inker. He does his own comics, and I remember this early piece that he did, and then Sunmin painted over it and it looked like an anime

background, but it looked like a merger between manga and anime," Tindle said. "And then the style just continued to develop and evolve as we got deeper into it. We cheated a lot. For example, we discovered if you have a rim light on a character, whether there should be one or not, it makes it feel more graphic."

Inn didn't watch the show – or any other TV – when she was a kid, but got into *Ultraman* when she was in college in Pasadena. She couldn't help but be worried, initially. "I was intimidated because it has so much history and I wasn't quite understanding what the relationship was with the older versions of *Ultraman* that had historical value. And it seemed like they want to do something completely different for the western kind of hemisphere," Inn said. "I was concerned that maybe doing something new and different might not be received with open arms, but Tsuburaya Productions, the folks who own *Ultraman*, they were so warm, welcoming, and they were very open to try something different."

One of the bigger challenges was being able to take the desired look of the film and get that across in 2D. The art department's goal was to get the images to about eighty-five percent in a Photoshop file, then work to get them to look right in 3D. One of the tougher aspects of this process was conveying the line work that the team wanted. The art department wondered, "How do we make the line on the characters and in the environment look consistent, without overwhelming our friends at ILM who are going to have to put it through an expandable pipeline?" Once they figured it out with ILM, with linework both baked into the designs, meaning they didn't have to art-direct or add any lines, and put in animation, with additional linework put in during lighting and compositing. This would emphasize the art style, inspired by comic books and manga, and also act to literally underline the emotionality of each scene and character. "Once that was worked out, we knew what we were looking at in the review, and we knew that each step along the way was just going to get a little closer to the final," MacVittie said.

The level of visual embroidery was always something that was being tested and adjusted.

▲ Some of the film's most iconic shots leverage what the team began to call, "Otomo moments," glimpses of pushed stylized color, motivated by a character's emotional state. Here is a flash of color with manga brush and ink treatments by Sunmin Inn for Ken's iconic final transformation into Ultraman in Sequence 4725, "HFS," (which the team will now politely say stands for, "Holy Flippin Stuff!").

Would the influences and the effects and flourishes ultimately take away from the story? Or would they, if used sparingly, make the movie better? "The name of the game is flexibility. Making a movie is messy, and you're constantly adjusting and readjusting. And I think that what was great about the people on this film was that we were all on it together, and if we

▼ This level of stylization was inspired by much of Inn's early concept work, such as this painting of Ultraman's transformation.

▲ Marcos Mateu-Mestre's tone key for Sequence 1900, "Dad." Mateu-Mestre took special care to create contrasts of light and dark, inside and outside, and calm and storm, to show the space between Ken and his father.

went too far, it was like everyone checked each other," MacVittie said.

Inn agreed, saying, "ILM helped to make it so that it's subtle enough where the lighting hits just right, and you see the cross-hatching and the manga stuff, but then it kind of disappears and turns a little bit more kind of watercolor-y, but not in a punchy way. Not in your face," Inn said. "Because, here's the thing, we didn't want the style to be distracting from the story, and that was something that the directors required and wanted since the beginning, and we understood that. So yeah, it was kind of figuring out the balance of what's unique enough, but not too distracting from the story."

Sometimes *Ultraman: Rising* really plays up the connection to the original series, like when the background turns into an unmistakable psychedelic swirl, or when Ultraman transforms towards the camera, in a herky-jerky stutter.

"Let's make it look cool. Let's make it look sixties, let's make it look manga, and there is all that, but in the right moment. In fact, the moments you see only stay on the screen for a very short amount of time," Mateu-Mestre said about their approach to the stylization. "There was a lot of discussion on that. There were all these moments and how we were going to represent them."

Mateu-Mestre continued: "Obviously there were moments that were going to look like manga with the dynamic lines and the texture, but making it look like it was brush work or pen work et cetera. That's one of the first things I did when I got into the show was I bought

▲ Another one of Inn's Otomo moments appears above, in the angry red background behind Ken. The other thumbnails show Gabriel Gomez's color keys for the sequence.

▼ Here, Inn explored an Otomo moment in that sequence, when Ken angrily lashes out at Professor Sato for being absent so many years.

myself a bunch of mangas, just looking and immersing myself in that. But there were a lot of moments that we had specific meetings...like, 'Okay, how do we represent that?'"

"It makes it feel more illustrative. We had paint strokes," Tindle said. "We wanted to incorporate some of that into it, and then keep the line work you would see on both anime and manga."

Tindle's approach to color, as mentioned above, was something that informed the design of the movie in a big way, with Mateu-Mestre pointing to a moment between Ken and his father on the steps of Ken's house. In that moment "everything behind him turns red because he's upset with his father," but then goes away. It's a way of heightening the moment, to emphasize a specific point, but also knowing when to fade back into a more naturalistic color scheme.

Also important in that scene: rain.

"One of the things that I'm always very keen on, and certainly, again, the directors wanted it too for the movie, is weather," Mateu-Mestre said. That moment between Ken and his father required a "quiet rain," while the big showdown at the end of the film is a "pretty bad storm." "That is again emphasizing the dramatic moment," Mateu-Mestre said.

▼ Here's an Easter egg: the sign of a father holding up his daughter is based on a photograph of production supervisor Stasia Fong being held by her father, affectionately known as "Papa Fong" to the team members who were lucky enough to get to know him.

Even the more heightened moments in the movie are designed to double underline the emotion of the scene. "The psychedelic aspects of it and the manga aspects of it and all that," Mateu-Mestre said. "Not only do they emphasize the moment in the story, but they also helped bring this sixties moment, cultural, iconic look of that time."

Mateu-Mestre describes the design process as imagining worlds within worlds – for Ken there is the human world, the baseball player world, made up of Japanese-inspired angles. Downstairs, in his Ultraman space, everything is organic and alien. The world of the KDF, Mateu-Mestre said, is a literal maze, made up of desks and screens and workspaces. Dr. Onda is "center stage." "It's like it's hard to get to this guy. It is hard to understand this guy. And so it was a bit of a labyrinth of offices," Mateu-Mestre said. "Each world had its own shape language." With each world more beautiful and more evocative than the last.

▶ Joe Feinsilver was tasked with designing Ken's stylish home's exterior, which he ideated in early art models, drawing upon extensive architecture and garden references. Ken's bedroom was designed by Mateu-Mestre and Minako Tomigahara, resulting in the ILM model you see above. Finally, the sunset view from Ken's living room was another collaborative effort between Mateu-Mestre and Ito, like the Ultrabase.

▼ Marcos Mateu-Mestre dreamed up Ken's secret base (coined "Ultrabase") that sits, hidden, beneath his house. In the top image, he mapped out the logistics. In the next, he collaborated with Yoriko Ito to create a vantage point from under water.

▼ Mateu-Mestre first drew Ken's "Man Cave" inside a secret base for *Made In Japan*. He made a few tweaks to the overall structure, and then handed the design off to Tomigahara for completion. Tomigahara was tasked with all of the set dressing, which includes enough Easter eggs for its own book. Here is one of her paintings, painted over a previs model by Justina Hnatowicz.

▲ Gabriel Gomez expanded upon Mateu-Mestre's initial design concepts for the KDF's incubator with this black-and-white texture pass. To its right, Adam Ely took on designing the KDF's control room.

▶ The directors hoped that the KDF HQ would be mysterious and enormous from the exterior, but even more labyrinthine and sprawling inside. Ely build upon concepts by Mateu-Mestre to create this shot of KDF gunships leaving the base, with an opening that looks like perhaps its underlying technology may have borrowed from the Ultrabase. To that image's right, another of Ely's control room designs.

▼ Ely also designed the KDF's Hangar, and painted this intimidating shot of the KDF lifting off in pursuit of Emi.

PRODUCTION

PREVIS

John Bermudes remembers it well.

He was at Sony Pictures Animation, helping out with previs on *Spider-Man: Into the Spider-Verse*. He heard that there was an all-hands meeting coming up, where various directors would outline the next ten projects that the studio would be involved in. Kurt Albrecht, a producer at the studio whom Bermudes had worked with on a small animated feature called *The Star*, encouraged him to attend the meeting. SPA hadn't been utilizing pre-visualization but they were interested. Albrecht encouraged Bermudes to meet with Shannon Tindle about his movie *Made in Japan*, before Bermudes left the studio.

Later at Netflix, Bermudes had a meeting with Tindle, in which they discussed all the work the latter had done before on things like *The Iron Giant* and *Osmosis Jones*. ("Shannon is a total animation nerd," said Bermudes.) Tindle and Aoshima said that they thought he would be a great fit for the project, but Bermudes paused. He hadn't made the connection that Tindle and Aoshima were working on *Made in Japan*. He thought that the filmmakers were working on a movie about the history of men and dogs (*Man's Best Friend*). "I said, 'What's the show? Is it the dog thing?'" Bermudes remembered. "And [Tindle] said, 'No, man, it's an *Ultraman* tribute.' Frankly, I jumped out of my seat."

He worked with Tindle and Aoshima (head of story at the time) and story artists for six months. *Made in Japan* fizzled out, as we have detailed earlier. And Bermudes went to work on other projects; he finished on *Spider-Man: Into the Spider-Verse* and worked on Glen Keane's *Over the Moon* for Netflix.

But let us take a moment to describe what previs actually is.

As Bret Marnell, the editor of *Ultraman: Rising* said, "Previs allows the creative crew to build a better blueprint. No longer are we bound by the staccato rhythms of still storyboards to convey smooth camera

◀ Previous spread: Color key by Marion Louw for Sequence 0300, "Meet Ultraman."

▲ Lighting script thumbnail by Marcos Mateu-Mestre for Sequence 0200, "Meet Ken Sato."

▶ Color key by Sunmin Inn for Sequence 0400, "Ken Sato Is Ultraman." Because this sequence was the first "city" sequence to enter lighting and compositing, it has more stylization cues than other color keys.

moves and dynamic action. Previs can create those images in a fast, efficient, and economical way that allows the editor to build a sequence where everyone can easily see the vision that the director has for the story."

Previs is relatively new to the world of animation but is utilized heavily in live-action, mostly on complicated action sequences. (Marvel Studios, for example, has gained a reputation for relying too heavily on previs when staging its action set pieces.) Bermudes describes it as "getting camera involved in pre-production." Storyboarding, which Bermudes said is still "super vital – important, very creative, very iterative, super-fast," is how story was conveyed earlier. A series of storyboards, strung together, allowing people to get a rudimentary grasp of what the story, action, and editorial will eventually feel like.

"There's a lot that's left out in storyboards. Basically the metrics of the space. There's no real cinematography in terms of scale and depth, and also there's limited camera moves and timing of action. It basically allows editorial to sort of find a deeper cutting pattern in that pre-production phase," Bermudes said. He shared a diagram where previs is at the center, both receiving from and giving to departments like editorial, the partner studio (in this case Industrial Light & Magic), design, and story. It is so integral, in fact, that it seems odd that it was ever being left out.

But how did Bermudes return for *Ultraman: Rising*? As it turns out, he just bumped into Tindle in the halls of Netflix. Tindle implied that *Made in Japan* might be back, with Aoshima later asking him, "How would you like to do real *Ultraman*?" Bermudes finished work on *My Dad the Bounty Hunter*, an animated Netflix series co-created by Everett Downing, Jr, who was in the story department of *Made in Japan* back at Sony. Then he joined *Ultraman: Rising*. It is unclear if he once again jumped out of his seat.

Joining him on the team was Stasia Fong, the production supervisor for previs. Like many people on the team, she was aware of *Ultraman* as a child. Her family is from Singapore, but growing up in Hong Kong, she remembers people dressing up as Ultraman for Halloween.

Fong was responsible for "managing more of the production side of things, so collaborating on the schedule, helping him with managing the artists and supporting them with what they needed in terms of the tools, when they would need materials from the story department or the art department, coordinating meetings with the directors so that Shannon and John could give their notes on the sequences, as well as also preparing all of the previs sequences for ILM."

"We had a lot of trouble at the very beginning figuring out how to create these CG [computer generated] environments where these massive characters like Ultraman and the baby *kaiju* can fit in there, but then it also won't look insane when Ken is in his human form walking around," Fong said. "And I think it took a really long time for the art department to get on the same page as previs in figuring out those logistics in a CG space, because obviously making a design in 2D is great and all, but if it can't fully be translated into CG in an accurate or appealing way, it just won't work, and it's impossible to shoot from a camera perspective." Fong said that it took a few months until they were all on the same page.

Together, Tindle and Bermudes designed a language for the camerawork of *Ultraman: Rising*. One example that Bermudes picked out that "really underscores the subtlety of the camera language," is that they wouldn't shoot Ken with any up angles at the beginning of the movie. "In the beginning it was either flat on or slightly down, and I never had him break top of frame," Bermudes said. Not only did this underline Ken's emotional/psychological state at the moment (stretched thin, feeling low, stressed out) but it also set up the relationship with scale – Ken is very small but Emi and the other *kaiju* are quite large. They can break frame. Tiny, insecure Ken cannot.

"The camera's going to be slightly down on him in the beginning and in his character arc as it starts maturing into the third act. And then when he reunites with his father and through the big battle and afterwards, then that camera starts dropping down slowly and you start getting these sort of subtle hero angles on Ken where he starts feeling more," Bermudes said. The camera follows his character arc from selfish to selfless – selfish (down angle) to selfless (up angle).

Tindle told Bermudes that he didn't want "these crazy lenses that you see in animation – lenses that don't actually exist." He also didn't want the camera moving in an unmotivated,

unrealistic way that you can see in some computer-generated animation. Rules were quickly implemented – if you're shooting human characters, the camera will be down with them, looking up. When it's just two giant characters, the camera was a little freer. Bermudes admits that they would "occasionally have fun with it" (how could you not?) But the commitment to realism was there. They had to pay close attention to distortion, because, as Bermudes noted, "There's simplification of character design and, if you get too distorted, they're off model. That's a fundamental difference between live-action and animation. You're a little more bracketed in terms of how much you can push that."

They decided that they would shoot in TohoScope, an anamorphic lens that was "basically a rebranded Cinemascope lens, squashing east/west to fit on 35mm." "You get specific lens flares from it, and any boca has a nice elliptical shape as opposed to a round iris." "Even though we're in a stylized world, let's have lens aberrations and flares that you would have from those lenses," Tindle said. The wider lenses also meant that you had to move the camera to capture all the action, which adds a certain dynamism to the look of the film. "If you're going to look at Ultraman, you have to adjust, which to me makes him feel *bigger*," Tindle said.

The filmmakers, Bermudes said, really wanted to lean into it. Oftentimes Tindle would ask, when the camera was moving, if they could have "a tiny bit of jitter in the way it would have been on an actual dolly track." He would experiment with cutting between extreme close-ups and extreme wide shots, like in the moment between Ken and his father (mirrored later in the film in a similar sequence between Onda and Aoshima), meant to amplify the discomfort and emotional unease.

This commitment to realism continued into layout. "One of my favorite things that our final layout team did was, if the camera is on Ultraman, and we don't have any of our normal scale cues, let's add helicopter jitter to the camera," Tindle said. "Because it's one of those things that you've seen in enough movies and it makes you feel scale because a helicopter needs to fly over it to see it."

As well as the realism, the filmmakers wanted to make sure film had the flare of the original series. "They were really into *Ultraman* and where it came from. And we based this *Ultraman* on the sixties show, which is pretty trippy," Bermudes said. He said he binged the Blu-ray box sets after getting the job, marveling at the combination of superhero action, *kaiju* stuff, and *Twilight Zone*-y elements. Some of the visual flourishes would creep into *Ultraman: Rising*. There were more in earlier versions of the movie but got pared back to the essentials as the production rolled along.

Fong said that it's hard to stress just how essential the previs process was to the making of the movie.

"It's super important. Even today, I feel like a lot of the executives don't often see the benefit in previs just because they're like, 'Well, you're going to do rough layout anyway.' But I feel like if you look at it in the sense that its CG storyboards, I think that kind of helps people understand just the value of it, because there's so much that you can obviously communicate within 2D hands-on storyboards, but when you actually try to explore things like scale and then action in particular in a CG space, I think it allows you to explore and discover so many different ideas that you wouldn't be able to discover within just drawing something," Fong said.

One such discovery, Fong said, was a moment in the beginning of the film when Ken is riding his motorcycle across the bridge into the city. It was something that Tindle had really wanted. "It was something that he had envisioned for ages in boards, but they could never really quite land on exactly what he wanted. But then the moment our previs artist took a stab at it, it was like, 'That's exactly what I want,'" Fong said. "That speaks volumes to just what previs can bring to the table early and in production."

The other thing that Fong wants to make clear is that previs can make sequences more emotional too. She points to the sequence toward the end of the movie, when Ultraman is about to jump on the robot (right before it explodes). They had rendered it in slow motion, something that wasn't in the boards. "And the fact that I think most of the times people see that, the characters aren't emoting. So it's not as emotional seeing the boards," Fong said. But the first time the previs team showed Tindle the sequence, he cried.

Fong actually made it into the movie, too. There's a moment when Ultraman stops Emi in the city. On one of the buildings there's a billboard of a father holding his baby. That's Fong and her dad. How cute is that? "Not every director would do that sort of thing for folks working on their movie. I think that's the most special part," Fong said.

Bermudes said that the communication, openness, and decisiveness between the departments led to a true anomaly in his experience. "It's the only time I'd ever worked on a film where every screening was better. It's usually, first screening can be a killer, second screening, maybe not. Then third screening loses its way, and it's ripped down to the studs. Fourth screening you're trying to recover and get lightning in the bottle," Bermudes said. "But I think pretty much all the changes were for the better and a more emotional deepening of the story, which I really, really appreciated. That was very satisfying."

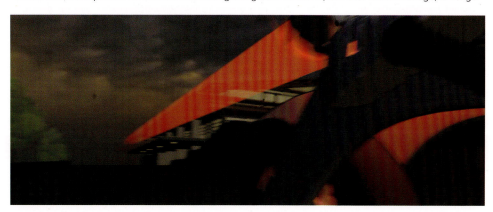

◄ John Bermudes prevised the shots of Ken riding away from his house, and over a secret bridge, to Tokyo.

ILM

Industrial Light & Magic is the fabled visual effects house founded by George Lucas during the production of *Star Wars* in 1975. Since then, they have won countless awards for their constantly groundbreaking work and, from a single crummy garage in Van Nuys, California, have expanded across the globe, with satellite studios the world over.

They have also, periodically, made animated features, most notably 2011's *Rango* from director Gore Verbinski, which won the Oscar for Best Animated Feature.

When *Ultraman: Rising* was being developed, ILM had just worked with director Shannon Tindle on *Lost Ollie*, an original series for Netflix that featured several computer-generated main characters created by the company's visual effects wizards. While they hadn't been in the feature animation game for a long while, inroads were being made. They had begun work on another Verbinski project (that would ultimately be abandoned), which, at the very least, opened up the possibility that they would want to work on another animated feature.

Ultraman: Rising producer Tom Knott was impressed with what ILM had done on *Lost Ollie* and suggested them for the job. When ILM were visiting Los Angeles, they swung by Tindle's offices. He showed them artwork and gave them the rundown of the story. "They loved it," Tindle said.

ILM's enthusiasm, coupled with their experience working with Tindle on *Lost Ollie*, definitely gave the effects house an edge. On the ILM side of things, Stef Drury, associate producer for ILM, and Hayden Jones, VFX supervisor, tried to push things along. Both natives of the United Kingdom, they didn't have much early exposure to *Ultraman*, but were still drawn to the story. "I think what always appealed to me was – even though it was a film with *kaiju*-sized babies and Ultraman is this 354-foot-tall superhero – that actually, it's a story about fathers, and sons, and relationships," Jones said. "And it has got a real heart to it. It felt like something really special."

Other vendors were still able to vie for the project, which they did. ILM knew if they wanted to win *Ultraman*, they'd have to provide an unbelievable bit of test animation.

"It was a look-of-picture because obviously one of the unique things about *Ultraman* is the style," Drury said. "I know the film comes out almost three years after the test, but I literally watched the test thirty minutes ago and it's like, 'Yeah, that's the film.'" And it's true – the test, which is just a couple of minutes long, shows the Baby bounding down a Tokyo street, with Ultraman chasing after her. There's a moment where everything slows down and the psychedelia of the movie takes over; missiles nearly hit our hero, the sky turns blood red, and

the light of Ultraman's eyes creates this kind of vapor trail. It's hugely impressive and, in just a few seconds, captures exactly the spirit of the finished film. Pretty impressive. Especially for something that ILM executed in just a few weeks.

"The tests are, to be honest, my favorite thing to do because I think there's just huge value and it just brings a reality, and an understanding, and a kind of real collaboration together," said Drury. "We had a couple of months to do it, but literally in three weeks we were like, 'That's the look we're going for.'"

"If you just look at it visually, what they were able to achieve in the amount of time, and I'm sure they put in more money than we paid them for the test, but what they were able to put up on screen in that amount of time was stunning," said *Ultraman: Rising* producer Lisa Poole.

Unsurprisingly, ILM got the job.

For ILM, the transition from feature work, where you are delivering exceptional *shots*, to a feature-length animated film, where the emphasis is on entire *scenes*, required some adjustment.

"I've done a lot of films, but more recently lots of episodic [work]. And actually the transition from episodic to feature animation is

slightly less bumpy because one of the things you're trying to do with episodic, with the time that you have, you're trying to [step back] and look at sequences," said Drury. "You're still talking in shots in episodic, but you are really trying to look at a sequence."

"I think that's one of the joys of feature animation is it stops being about single shots. You are looking at entire sequences, and you are bridging sequences as well," said Jones. "You have to look at how each sequence flows into each other so that you can judge stylistically how the film works. It makes you feel like you're closer to the story as an artist on the film, because you can see how your work is affecting the wider movie. And I think that's really rewarding."

To help, there was also a new review tool that was implemented called Sync Sketch, which allowed for the end of the previous sequence and the beginning of the following sequence to be played in review, so, as Drury said, "you always are looking at things in context." He said that in his twenty-five years in the business, that's the thing that he's reminding people about the most – context. "That's obviously a really bad habit in visual effects," Drury said. But with ILM taking on more feature animation work and working with tools like SyncSketch, it is moving in the right direction.

▲▼ ILM's final rendering of the KDF Jet, as seen in the epic chase in Sequence 1600, "Sky Battle."

▲ ILM expertly brought us along Emi's adventure through the streets of Tokyo.

▼ Here, they leveraged their world-class effects experience, to give us three different blast styles, as well as rain and a roiling ocean.

"Every time you are looking at a sequence of shots, you are instantly drawn into the narrative and your eye is supposed to be where the director is aiming you at," Drury said.

They also had the help of legendary animator James Baxter, who was working with Netflix Animation and, in the early days, would provide lectures "about variation in style, how anime animation varies from more traditional western animation, some of the nuances you can bring to bear with that," said Jones. "And then just generally talking about the level of character and the level of subtlety that's required in some of the quieter moments in the movie."

Industrial Light & Magic is known for contributing a level of hyper-realism on fantastical projects, bringing the worlds of *Jurassic Park*, *Terminator 2: Judgment Day,* and *Pirates of the Caribbean*, plus countless superhero sagas, to life in ways that make the audience believe everything happening on screen. For *Ultraman: Rising*, the team was asked to pivot, hard, into a stylized visual language informed by *Tokusatsu*, manga, anime, and the like. They were up to the job.

"I think everyone was worried about the stylization and the potential uniqueness of almost everything," said Drury. What helped was that the team had worked with Tindle before, and that the filmmakers had a direct line of communication with the animators (and vice versa), creating a very open and collaborative environment. "Everyone is invited to all of the calls, everyone's name is on their work so they can be spoken to directly. And it shocked a lot of people at ILM who are not used to having the director talk to them because, sadly, the way visual effects has gone, you have more and more people that you have to go through."

In terms of stylization, Jones said the different preconceptions of how anime and manga should look really came through. In addition, the artwork that was presented to ILM was a melding of different Japanese influences. "It wasn't anime, it wasn't manga, it was a melding of the two," said Jones. "A lot of the style came from assessing how you achieve some of these looks physically. There was a lot of marker work, there was a lot of ink line work, that kind of pantone work... traditional cross-hatching as well. There's a number of techniques that all kind of meld together to give you this palette of stylization."

The team also had to figure out how these techniques, which Jones describes as "intrinsically 2D," could be applied to three-dimensional objects. Tindle didn't want to flatten the image too much; losing depth would impact lighting as well as the camera's depth of field. The team was already going out of its way to add dimensionality, via lens flares and other embroidery, so flattening the image would be out of the question.

"We experimented for a long time... so for cross-hatching, we have three different solutions; some of them work in 2D, some of them work in 3D, and you choose on a shot-by-shot basis which one's going to work best for that shot," Jones said. "And then you look at it as a sequence and you make sure it just feels as seamless as possible across the sequence. When it works beautifully, it gives you the style, but it's tricky. The style was a huge challenge."

Jones sought to "find people inside of ILM who'd worked on animated features in the past and help bring them on board to *Ultraman*," but they also looked externally to hire people, "with strong animation skills, so that we could make sure that we were

▼ ILM had a big task ahead of them, in executing the titular character. Here is a Style Guide page provided to them by Sunmin Inn. It was up to them to figure out how to achieve these details in a scalable way.

▲ Alicia Journet, the look development lead, contributed to these final renders of Ultraman.

▶ Sohan Chaudhari handled the final compositing on this "Otomo Moment" from Sequence 4650, "Battle Mode."

getting people who could bring all of the characters to life in the way that Shannon wanted."

In 2021, they had about six months just to develop what Drury called the "look of picture." ILM focused on two key sequences: a sequence between Ken and Ami in a noodle restaurant, which was very performance-based; and a more outsized action sequence that saw Ken (now as Ultraman) chasing the Baby around the city. (The second sequence was, in effect, an expansion of the original test that ILM had completed which had so dazzled the producers and executives at Netflix and Tsuburaya.) "We were fortunate enough to be able to work through the look over that kind of six-month period whilst we were building assets," Drury said. "Obviously there's a huge world that we need to build before we can get into shot production."

This period, which Drury said helped the production "find its feet," allowed them to ask: "Will it work for the whole movie or what are the limitations?" There were some difficult conversations during this period, where the ILM team would be "over-noted" (in Drury's words), and the ILM team told the filmmakers that they aren't going to be able to art direct every shot. For the ILM team, their mantra was to under-promise and over-deliver. "If you spend time giving us all these notes and we try and hit all of these notes individually, it's going to take us much longer than if you give us your overriding note," Drury said. Eventually, Drury told the filmmakers: "We want to be able to give you absolutely everything that you want, but you literally cannot comment and draw on every single frame."

Eventually, the ILM team got into a groove. They relied on Tindle to look at a collection of shots, or an entire sequence, and give notes on how he felt about the work being presented. "It's not over-noted and it's not going backwards and forwards frame by frame," said

Drury. Instead, the team would show fifteen shots – they'd get it in sequence with audio – and they'd get two or three notes back, from Tindle or Aoshima.

Tindle also appreciated their openness and honesty, especially when it came to the budget.

"The other part of our relationship was we don't have $200 million to make this movie," Tindle said. "We'll talk it out and we'll find solutions that we can do with the budget we have. So I think the film looks every bit as expensive as something that cost way more than our film did, but it's the bonus you get when you have history working with brilliant folks like Stef and Hayd."

Further complicating matters was that the *Ultraman* workload would be spread across several ILM studios around the world – Singapore, London, and Vancouver. Tindle admitted that he was initially unsure of Singapore, since he hadn't worked with them and wasn't aware of their output. Until, of course, he saw their reel, with shots from *The Mandalorian* and *Avengers,* quickly changing his attitude. The Singapore studio wound up doing thirty-four minutes of the film. "And it's exceptional," said Tindle. Sadly, the Singapore ILM studio shut down shortly after completing work on *Ultraman: Rising*. But their work in the film provides a living testament to their artistry, ingenuity, technical knowhow, and unending creativity.

On working with Industrial Light & Magic, Tindle said, "Everybody brought their A-plus game. If I have my way, I'm going to work with ILM for many years to come. I just love working with those folks."

It's easy to see why Tindle would be so bullish to reunite with Industrial Light & Magic – *Ultraman: Rising* provides animation and effects that are unlike anything ILM has done before. And unlike anything you've ever seen in animation.

▲ Nacho Molina provided the Mech's final color and texture; his black and white linework pass is on top, with the full color pass below.

▼ Ryo Yambe's designs for the Mech, which emerges from the KDF Destroyer.

▲ On top, ILM showed the final rendering of the Mech, staged inside the Ultrabase. Beneath are some final shots of the Mech in action, which show ILM's incredible capabilities with lighting, compositing, and effects.

PRODUCTION LEADERSHIP

Any movie is only as good as the team behind the scenes. And *Ultraman: Rising* had a team of all-stars who worked tirelessly to keep the movie charging forward. Why don't we get to know them a little better?

▲ The production team was incredibly close, as evidenced by producer Lisa Poole posing for a picture with production coordinator, previs and editorial, Cristina Fabular.

▶ Many members of production leadership, as well as London ILM crew members, can be spotted in this snap from a wrap party. Among those included are producers Tom Knott and Lisa Poole, production manager Maddie Lazer, and ILM production leads Stefan Drury, Sean Murphy, and Nathalie Le Berre.

TOM KNOTT, PRODUCER

Thanksgiving 2010. Shannon Tindle told Tom Knott, a legendary recruiter and producer, about his idea. At first it was *Made in Japan*, but later became *Ultraman: Rising*. Whilst Knott wasn't exposed to *Ultraman* growing up in Southern Ontario, Canada, he knew that Tindle's pitch was great.

When Tindle took the project to Sony, Knott wasn't involved. But when it moved to Netflix and became a really-for-real *Ultraman* movie, Knott came back. "I was the first person hired after Shannon," Knott said. By the time *Ultraman: Rising* comes out, Knott will have been with the project for five years.

"I thought it was a cool idea. It's interesting that the character's been around since 1966. There's been many, many different iterations of Ultraman. Ours is different [again]. I keep saying we're not making an *Ultraman* film. We're making a film that features Ultraman, but it's not an *Ultraman* film. It's a film about family, and fathers, and daughters, and that relationship," Knott said. He points to the fact that "everything Shannon has almost ever done has been about family." Even the Google VR short that Knott and Tindle made (*On the Ice*) had ties to Tindle's family – it was made for his uncle, "one of the funniest people I've ever met," said Knott.

On other films, Knott said, he was responsible for working with the directors and producers and "putting the team together." He is always struck by directors who "know what they want." He points to *Coraline* and *The Iron Giant* as movies which were better because there was a decided lack of studio participation and input. "On this film we got notes and everything else, but it is a

director's film," Knott said. "The same with *The Iron Giant*, the same with *Coraline*. That's Henry's film. It's Brad's film. This is Shannon's film, so you know who the author is," Knott said.

Knott said that often in the studio system, the movie gets muddled by the number of directors, and executives, and marketing teams. "It's so different, and in my case better, to work with a director who knows what they want," Knott said.

One of Knott's roles was to interface with Tsuburaya, who he describes as "great partners." "Their concern was we weren't going to do anything that could damage the *Ultraman* lore. And they quickly realized that we were on the same page. I do think there was some concern just because our Ultraman is fairly different than what you've seen in other [media]. The Ultraman in our movie is a dad, and we show the family aspect of that. To me, Ken Sato is the ultimate mama's boy, even though in our film you only get glimpses of mom. This guy's a mama's boy," Knott said.

Knott said that there are plenty of nods in the film to *Ultraman*'s rich history, most specifically *Ultraseven*, which was Tindle and Aoshima's favorite series. "It's a reason to watch the film more than once," Knott joked.

Much of *Ultraman: Rising* was produced during the 2020 COVID-19 lockdown. "It did not affect the quality of the film at all," Knott said. But it was still the biggest challenge on the film. "Everybody was hired, and started working, remotely," Knott said. He worried that people not being able to physically be in the room together was going to impact the project, but with Tindle and Aoshima hiring the story teams (and knowing them so well already), "there was

▼ You can spot a character based on Tom Knott as a Giants fan in the stands, screaming, "You suck!" at Ken Sato.

already a way of working together." He fretted more about the art department. "That probably took a bit more work to get everything to work well together," Knott said. "Even if we were in the studio, a number of our artists were outside of the country anyway, and they had been used to working that way already."

Knott said that, as a producer, if you do your job right, you can step away and let everyone else do their job. "The team that we put together was a really good production management team. They were good at what they did, and you just try not to get in the way," Knott said.

Ultraman: Rising survived, among other things, a change in executive leadership at Netflix. "In the end, everything worked out," Knott said.

Looking back on his *Ultraman: Rising* journey, he is amazed that "ninety-five percent, maybe higher," is Tindle's original vision for the project. "You can go back and look at the first draft, you can go back to our first conversations and the first conversations with John. I don't think it's changed much. The center of the story has always been family and that's all there. That's the core of the movie," Knott said. Tindle would always listen to suggestions, from just about everybody, but if the input was taking the film in a different direction, he would listen but not budge. "That's not the film we were making," Knott said.

▶ Several members of the *Ultraman: Rising* team collaborated to keep an eye on the film's cultural authenticity. Pictured here: Riku Ito, Makiko Wakita, Ryo Yambe, Minako Tomigahara, Yoriko Ito, and Rie Koga.

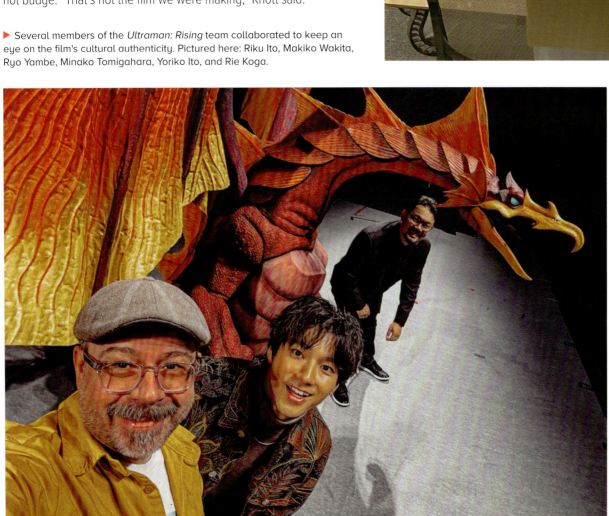

What about the biggest surprise making the film?

"The biggest surprise, and I shouldn't have been surprised, was the score," Knott said. There was some concern from executives because Scot Stafford hadn't "done a movie this big." But he had done a lot of projects before and worked with Tindle on *Lost Ollie* and *On the Ice*. He remembers the score being recorded and hearing it with the full orchestra. "The first sequence after the title with Ken, and mom, and dad, that brought tears to everybody," Knott said. "Just hearing it for the first time, I stood up and applauded. That was one of the first things we heard. And then there were things that we knew would be good, that were even better."

Knott is also super proud of the number of first timers who worked on the movie. There were trainees who worked on the story team. It's Tindle's first feature, from beginning to end. It was Knott's first film as a producer, Marcos Mateu-Mestre's first as a production designer, Sunmin Inn's first as an art director, and Maddie Lazer's first as a production manager.

"We had a lot of people who, this is their first feature with those titles, but they had lots of experience and they all worked well together. I don't like using the term family in animation because you've come together for four or five years and everybody goes their way. But it was a really great collective, a really good team, and they really worked well together. I mean, I've never seen anything like it," Knott said.

◀ Shannon Tindle and John Aoshima posed with Yuki Yamada, who voiced Ken Sato and Ultraman in the film's Japanese dub.

LISA POOLE, PRODUCER

Unlike Tom Knott, Lisa Poole had worked as a line producer on several projects. In fact, she was just coming off of Disney legend Glen Keane's *Over the Moon*, one of the first big Netflix original animated movies. As she was finishing up work on *Over the Moon*, she was approached about *Ultraman: Rising*. "My first reaction was, 'I'm not your girl because I don't know superheroes.' I'd never really heard of *Ultraman* other than knowing that the project was around the studio. And I can't tell you which superhero comes from which original source. I just don't know," Poole said.

This all changed, of course, when she met Tindle and Knott. "I learned more about the experience they wanted the crew to have, and I realized we were aligned on how to run a show, the experience we wanted the artists and the production team to have," Poole said. And then she read the script and realized it wasn't really a superhero movie. It was something very different (and something way more relatable). "Yes, he is a superhero, but it's really a movie about family, and that I can understand, and that I can support and feel like I have something to contribute at some level," Poole said.

Even Poole's lack of knowledge surrounding the character turned out to be a feature, not a bug. "In some ways my role, as we've gone through, has been to be that fresh eye that doesn't know *Ultraman* to say, 'Well, what does this mean?' and, 'How does that make sense?'" Poole said. "Is there something else I need to know to understand this? Or are we being clear enough that people like me can appreciate the movie?"

As nerve rattling as it is to be embarking on a new take on a beloved character, Poole said that she felt even more pressure to get the movie right "culturally." "The story, in and of itself, being about family, that's a universal story," Poole said. The question became "how do we tell it in a way that feels authentic? That was a bigger concern, and we spent a lot of time and energy trying to get that part right," she said. Poole continued: "You want the environment to feel as real as possible. You want the way the characters interact to be culturally authentic."

The team hired a Japanese cultural consultant and collaborated with the Japanese American Cultural & Community Center in downtown Los Angeles, who had an expert who gave multiple lectures on food, family interactions, and other topics. "And then there were a number of Japanese or Japanese Americans on our crew who were kind enough to volunteer their time to review everything and give us notes," Poole said. "Every week we would meet and they would have reviewed the most recent artwork, the latest version of the script, if there were sequences coming through that we wanted them to take a look at."

As Makiko Wakita discussed, this team would give very specific notes. "There were times where the directors would say, 'We understand that that is the exact way to do it, but since we're not making a documentary or a photoreal movie, creatively we do want to lean this way on this particular thing,'" Poole said. "And then there were other topics where the directors were like, 'Nope, we're going to change it so it's more authentic.' And I would say there were more decisions that leaned in the direction of authenticity than in the creative license direction."

Poole said that she loved working with Tindle. "Early on, I voiced an opinion about something and he didn't agree with it, and I could tell he was trying to be delicate about how he was telling me he didn't agree. And my point to him was, it's okay if we don't agree. If we can just talk about it, then that satisfies me. But it's okay. We are not going to agree on everything," Poole said. She appreciated that Tindle would listen and sometimes it would take a couple of days "to absorb and rethink and come up with his idea for how to solve the problem your note is addressing," but he'd do it.

Tindle and Aoshima's decisiveness was appreciated. "They're very respectful of the contributions, not just of the artists, but of the production management team. They were both very vocal in their appreciation to people, which makes people just want to please them more," Poole said.

Incredibly, Poole was on the movie for over a year before she was in the room with the rest of the team. And, once with the team, she still remembers the very first shot in animation that made her laugh: it was the shot of Emi in the tube when she turns her head and she's trying to lick the glass because Ken is eating a donut outside of the glass. "I died laughing. And to have that emotion in rough animation was delightful," Poole said.

One of the things that Poole really wanted was for Maddie Lazer to be a part of the team as production manager. She had worked with Lazer on *Over the Moon* and acknowledged her "desire to learn and grow." "I just felt like she could do this movie," Poole said. Initially, the studio wanted to have both a front-end and back-end production manager, which is understandable given the size and complexity of the movie. "I personally felt that she could manage the whole thing, but sometimes, particularly when you're new to a team, you have to pick and choose your battles," Poole said. Lazer agreed. And they started interviewing for the other production managers, but they never found the right person. By then, people around the production were starting to see what she was capable of. "That requirement eventually just went away because she's so very good at what she does. And I love that she not only has the organizational skills because of her background, [but] she [also] has a very good understanding and awareness of technology and what you can do technically," Poole said. "And when people need to talk tech, she can understand and have a conversation about that. You top that off with her people skills and she's just unbeatable." Poole added, "I'm pretty convinced I'll be working for her someday."

Poole seems genuinely moved by her experience on *Ultraman: Rising*. "They're smart and kind people. They're very supportive of each other," Poole said. "We had a lot of people go through really difficult things, health scares and situations, deaths in their families. My father had a stroke. Real big life issues that people had to deal with — family members with cancer, themselves with cancer. And instead of the team falling apart when those people had to be out, people rallied and asked, 'How can I help? I can take this part of that job. Let me fill in here.'"

Knott might be hesitant to call the team a family, but that sure sounds like family to me.

Tindle says, "This film wouldn't be possible without the experience, skill, and kindness of our producers and the production team they recruited. You don't find folks like Tom and Lisa very often. When you do, pray you get the experience of working with them in the future."

▼ Color key by Gabriel Gomez for Sequence 2800, "Ken Throws A Tantrum."

MADDIE LAZER, PRODUCTION MANAGER

Maddie Lazer, the production manager of *Ultraman: Rising*, came from *Over the Moon* with Poole. She talked to senior leadership and expressed her desire for the various teams to work together, instead of being siloed. "My approach was very much, 'I like to be in the meetings, not to sit and give a million notes', but just because I think the more you know about what the creative vision is, the more you start to understand your directors and your department leads and what they're really after, the better you can do your job and make it all happen," Lazer said.

Knott and Tindle were very open to it. "Maddie is the glue that unites our departments. She is a genuine force of nature, and an incredible communicator," says Tindle.

"It seemed like a good fit for me to enter the leadership team. And I think that over the span of production, we had a lot to learn about each other, a lot to learn about the movie's needs. But we really figured out, I think, hopefully: how to make a good movie together and also really prioritize the crew as part of that," Lazer said. She considered, "'How do we do this in a way that doesn't work people to dust? How do we do this in a way where they feel they have actual input and creative stakes in it along with everyone else?'"

Lazer was not a fan of *Ultraman* before the project began but, after she was given a rundown of what the story was (and how the earlier iterations of the character would differ from the version of the character dreamed up for *Ultraman: Rising*), she did her research. She was also told how many people in the world know about the character, and how awareness of the IP compares to some of the western superheroes she was probably aware of. "I was like, 'It's *so huge*,'" Lazer said. "I think it was really cool to come, in a way, without preexisting knowledge; I could sort of sit back and see the different ways that people think about this character and what really matters to core fans; what new fans are expecting coming into it."

Working with Tsuburaya Productions was a dream, according to Lazer, especially after she had heard horror stories about working with IP owners and "it being a very restrictive, prescriptive process creatively, in terms of what they're looking for out of the character." The Tsuburaya team, crucially, had "foundational expertise in this character and also the perspective on what the character means to existing fans," Lazer said, but were always great about having conversations regarding how the character could change for the purposes of *Ultraman: Rising*.

On the animation side of things, Lazer had her work cut out for her. She said that the challenge in animation is typically multifaceted: "Can you establish your style and make sure that this is something that is achievable for a production partner? [Aim high], but you don't want to push for something impossible. And then beyond that, how do you get the story on rails where everyone's basically okay with what's happening as you move forward?" She said that the style part came fairly easily, thanks to the art department. (It helped that there was a wealth of material from the early Sony days of *Made in Japan*.) As the story developed, they would identify sequences and scenes that could be pushed forward, with characters and sets that you knew were going to get used. They were also establishing what the story would be. "It is not a plug-and-play superhero arc. It is its own thing," Lazer said. "It's *Ultraman*."

The first sequence they put into production was Emi playing baseball. "If you think of it production-wise, Ken's [definitely] in the movie, baby's [definitely] in the movie, you definitely know baby's going to play baseball – [it's] the cutest, best thing ever. This sequence is definitely happening," Lazer said. "And it was really one set, effectively speaking and it was also great because that's a sequence where you see your characters wide, you see them up close." It allowed the team to answer questions: How does the baby run? How does she react when she gets hit by a ball? What does water look like in the movie? What about tears? "It was this really amazing moment to figure out a lot of [questions] while we're still pushing it forward," Lazer said. "It unlocked a lot for us."

Lazer took note of the appropriate amount of lore to explain what *Ultraman* is, versus just letting

▲ Emi's acid reflux gets the best of Ultraman in Sequence 3350, "Baby's Night Out."

the audience catch up with the mythology. "Something that our filmmakers are very averse to, and I appreciate this about them, is the spoon-feeding of information to audiences. We didn't want to do that," Lazer said. The team leaned towards keeping things "more ambiguous," inspired by other movies that simply plop you into the middle of the action without much explanation. (*Raiders of the Lost Ark* and the original *Star Wars* are great examples of this.) They came up with a system that would designate whether or not exposition was required: "Our rule of thumb is: if it takes you out of the movie and distracts you... you're wondering, 'What's happening?' That's not good. If you *finish* the movie and wonder, 'What about that thing?' that's probably okay," Lazer said. They would get feedback from audiences, along with Netflix leadership and the team at Tsuburaya, and adjust accordingly.

A lot of what Lazer did on *Ultraman: Rising* is incredibly complicated and deeply essential, including the automation of tasks that would normally take humans an ungodly amount of time to complete (not AI, mind you, just computerized tracking of shots via a collaborative system) or delivering materials back and forth with ILM, post-production, and marketing. ("Our deliveries took two minutes to ingest versus an hour"). "If you think about what that does to someone's productivity – the other things they can focus on – I think that actually is probably the underlying reason we were able to even have the brain space to think about other efficiencies," Lazer said.

"It's just that true collaborative spirit underlying everything," Lazer said. "And also hiring people who are super passionate about what they're doing. They're not coming in just for the paycheck. They're coming in because they care about the movie, they care about their staff, and they want it to be a good experience and a good movie."

When asked what she was most excited about, in terms of the movie finally coming out, Lazer said, "I think what I'm most excited for with this movie is that no single thing is the star of the show. I guess what I mean by that is, we're all used to seeing movies and saying, like, 'Man, what a story. I was so engaged, but... it didn't look that great.' [Or vice versa]. I think particularly for animation, you really feel the price point sometimes. And this one, I don't think you're going to question the price point at all. I'm so proud of how it looks, but *also* the story's good, but *also* the camera is really finessed and great, but *also* the effects are amazing and stylized. It's like every level of this thing I feel came together. And I think one of the things that I'm – I don't even know if proud is the right word, because everyone shares responsibility for this, and not just me – but, one of the things I'm proudest of is that we have had several people at ILM or front-end say things to the effect of, 'I've been in this industry a long time, and I've never enjoyed working on a movie as much as this one.' I'm very happy about that."

And Lazer's commitment to *Ultraman: Rising* continued even after the movie was done. Without her, this book wouldn't have been possible either.

▼ Members of the ILM Vancouver team stopped to snap a picture with members of Netflix's LA team, including Shannon Tindle, John Aoshima, Tom Knott, Lisa Poole, John Bermudes, and Stasia Fong.

ANIMATION

Animation supervisor Mathieu Vig was working on Marvel's *Eternals* when he got the call. *Ultraman: Rising* needed him. "They were looking for an animation supervisor that could do something obviously very different from what ILM does usually, which was a feature animation," Vig said. And it was true. This was outside the normal Industrial Light & Magic wheelhouse. Vig had some traditional animation background and it seemed like, among the people at ILM at the time, as Vig said, "I could somehow fit into the role and change the style of animation that we usually do and do something much more cartoony, much more graphical, and much less VFX-ish than what we do day-to-day."

Vig said that while feature animation was completely new for a lot of people, there were a lot of reflexes that the animators have from their VFX experiences that could bring "some nice little subtleties and a different point of view on the classic feature animation style. From the get-go, I think it was a really interesting mix of people and being almost too realistic in some ways, but also trying to get back to the roots of proper, classic, cartoony, crazy animation that people love to watch and we don't do generally," Vig said.

Director Shannon Tindle wasn't too specific about the animation style that he was really after, at least initially. "I think he was really interested in talking about the story, the themes of the movie, and the feeling that he wanted people to get out of it. We barely talked about giant *kaijus* and big battles, and we talked much more about fatherhood, raising a child, growing up in your own role," Vig said. He thought the discussion was going to be very specific about how stylized Tindle wanted the animation to be and the references he had in terms of anime, manga, and anything else. They talked about that a little bit. But it was more about creating a story that brought these characters to life outside of what was normally expected from this type of movie.

"I think when you watch the film, there are battles, there is drama and action, but before everything, it's a character story. It's a sort of coming-of-age, fatherhood story," Vig said. His daughter was two at the time that he started on *Ultraman: Rising*. "She was exactly at the right age and I had the same sort of questions, obviously, 'What the hell am I doing?'" Vig said. Unlike Ken, he very much wanted his baby. "I had the perfect reference trotting around in my lounge while we were discussing the movie," Vig said.

In terms of references, Tindle suggested that Vig watch *Kramer vs. Kramer*, the Best Picture-winning custody drama starring Dustin Hoffman and Meryl Streep. Vig thought this pick was "unexpected." He'd never seen it before. Tindle insisted. "He was really focused on this relationship and the changing relationship between this father who just doesn't really want to be a dad. He's not really interested. And then the moment he switches," Vig said. Shortly after, the team worked on a couple of test sequences. "In those sequences, we had to put this in

▶ Tony Fucile helped with initial rig tests by providing pose studies, and drawing over first passes from ILM.

action and try to show this fatherly horror as soon as something happens to your baby," Vig said. One of the sequences was when Emi escapes and climbs the tower, falling and breaking her arm. The other sequence was the scene of Ken and Ami in the restaurant. The filmmakers were interested in the look of the animation – in how fluid it was, in how striking the posing could be – but Tindle and Aoshima's notes were "rarely about the animation itself."

The notes instead were about acting and emotion. It reframed how Vig (and the rest of the teams at ILM) were meant to work. "That meant we could take care of the details and the quality of the animation itself. And he just wanted to have his characters alive and believable in the reaction they had, in the acting they had," Vig said. "He didn't want any kind of cliché animation." Vig admitted that the team would occasionally try and sneak a few in ("because we've all been raised watching the same movies"), like the *Aladdin* neck rub (a newer variation of the Baloo neck rub from Disney's *The Jungle Book*). But this wasn't that sort of movie.

"For a lot of the animators, it was a very new experience to purely deal with acting notes and performance notes and not have a director who is really focused on, 'The pinky is not moving in the right position.' He didn't care about that," Vig said. "He would let us worry about making sure that we would solve it. But I think as soon as he saw that the sequences were taking shape in the way that he imagined, he just really stopped worrying about the details and just worried about his virtual actors."

The actors were filmed delivering their lines, which the animation team would utilize, at least at the beginning. "It felt a bit too stale, I think for him," Vig said about Tindle. "I think one of the rules that we had on the show was that in every shot we were trying to sneak in one of these little accidents that people do when they talk, when they grab something or things where you miss; you try to hold something, but you have to do it twice, you trip a little bit. You have this sort of random look around that people do when they just talk, that usually when you do a feature animation film, you filter out a little bit to go to a nice pose or a nice silhouette." Any shot that didn't adhere to this philosophy, Vig said, "felt a little bit too animated." The team was always trying to sneak these moments in. If a character moved in a curve that felt too perfect, they would try and break it up. Tindle loved the acting that was being delivered, "he was trying to get us to filter out a lot of the unnecessary stuff while keeping some of these little accidents that give it a bit of soul, a bit of texture to the animation."

Vig said that the final animation had to "balance between fluidity, shape, silhouette, but also the little dirt that you have in real life."

There was a lot of discussion about how they would animate Ultraman himself, including whether his jaw would move when he was speaking. Ultimately, they decided that it was "absolutely forbidden" for his jaw to move or for him to have any sort of lip sync. But when they landed on his eyes ("Can he look somewhere else and where is the glowiness happening?")

▼ Professor Sato councils Ken on what it truly means to be Ultraman. Animated by Po-Chen Wu.

and gave him an interior light that suggested illuminated pupils, it "immediately changed the tone." "It turned from almost having narration to a character talking," Vig said. Other questions followed – how would they handle scale? If Ultraman and Emi were seen as too big or too lumbering, it would lose "the appeal, the snappiness, and sassiness" of the characters. The "blurry rule" they came up with was

that if they were together in a shot by themselves, Vig and the team would "animate them pretty much as if they were normal characters." If they were seen by other people, with human-sized characters or cars, they would "try to exaggerate the weight and make them a little slower, a little heavier and make them act a little less snappy." This was not set in stone but was rather a guide for the animation.

▲ Ken and Professor Sato gaze out over a mountainous area in Japan, near their family's cabin.

▼ Marcos Mateu-Mestre's lighting script thumbnail and Marion Louw's color key for Sequence 4200, "Finding Balance."

Among other things, Vig also leaned on the right ILM outpost for each job, since *Ultraman: Rising* utilized the London, Vancouver, and Singapore offices. The sequence with Ken and Ami in the restaurant went to Singapore, for instance. "They were very good at those very quiet, but very detailed sequences," Vig said. "It was a new thing for a lot of people. We've done dinosaurs, we've done big battles, but this long keyframe shot of people talking was a real joy for everyone."

Of course, aiding him in the animation department was Tony Fucile, a legendary animator who served as head of character animation. Fucile got his start in animation at Disney during the 1980s, working on the movies that Vig and the other animators were looking to for inspiration; he was the lead animator for Aladdin in *Aladdin* – that neck rub was his!

"We needed an animation legend to oversee and even uncover some of the VFX defects that we might have," Vig said. "Tony came in at the beginning and he did a couple of amazing 2D animation tests for the main characters. And he just has this eye for consistency, for the consistency of face shapes, of poses, all the little details that we might miss on the craziness of the day-to-day." Fucile provided "the final seal of approval" on animation.

"He's been doing feature animation for so long that he really has this eye for staging, for placing the characters at the right scale, at the right position on screen. And it's a very fast-paced turnaround for us, of course," Vig said. "We try to get away with some things, and I think Tony's here to stop us and to say, 'You know what? This one, let's just add five little percent to the shot with these couple of poses, these couple of shapes.'"

Fucile, for his part, had watched *Ultraman* beginning in the late 1960s thanks to a local channel in the Bay Area that would play them after school. "I watched that show a lot when I was a kid. I loved the story," Fucile said.

While he and Tindle had known each other for a while (Tindle tried to recruit Fucile to help with character design on *Kubo and the Two Strings*), Fucile was at Netflix as part of a group of senior animation leaders who would be lent out on various projects – he touched *Klaus*, the Oscar-nominated *Sea Beast*, and other features, some of which never saw the light of day. "The idea was that we were all little bees, we buzzed around wherever we were needed," Fucile said. When that group was disbanding, Tindle asked Fucile if he wanted to come onto *Ultraman: Rising*.

When describing his role, Fucile said, "I'll make suggestions and the directors will look at them and decide whether or not they want to do them. Luckily, most of the time they're pretty good about taking some of the ideas."

This is selling his contributions short. He worked with the team on lip syncing, because he said, "lip sync in a kind of caricature film is a little different than more of a visual effects-type movie." He said that it was fun because so many of the animators had such different backgrounds – some were character animators, others effects animators, others focused mostly on creatures. "I do full, Golden Age-style animation," Fucile said, which encompasses "the clear phrasing, and pushing the poses, and caricature, and all that kind of stuff."

When Fucile joined the production, it was moving full steam ahead. He didn't do any design work or any articulation. He would suggest tweaks to the posing of certain characters and work on the facial animation of others. These suggestions would come courtesy of Fucile's famous "draw-overs," a practice that began, rudimentarily, on Brad Bird's *The Incredibles*. By the time Pete Docter's *Inside Out* came around, his expertise was fully a part of the pipeline. With *Ultraman: Rising*, he would get granular.

"It runs a gamut between pushing stuff in a gestural sense, and then getting really, really specific, even down to a tongue between the teeth and then just popping a jaw, really specific stuff within the dialogue," Fucile said. "The thing about *Ultraman*

▼ Sunmin Inn's color script thumbnail for sequence 3350, "Baby's Night Out."

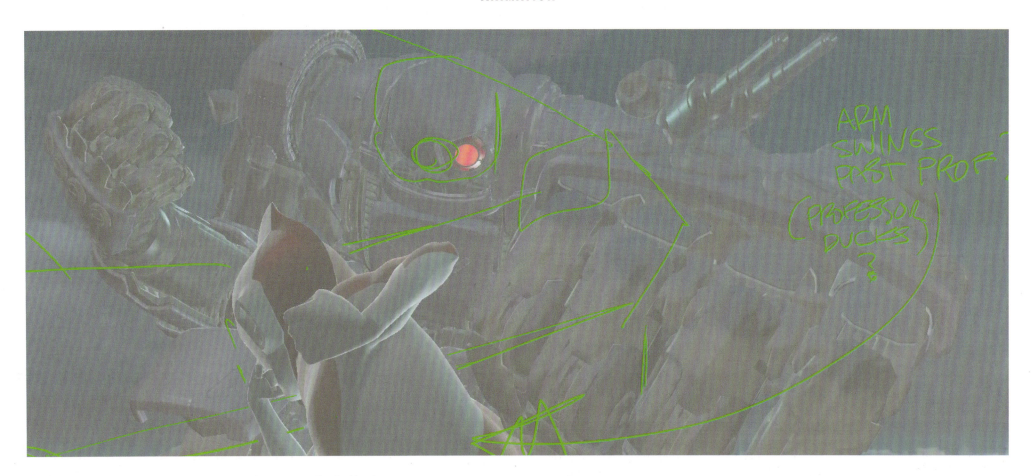

▲▼ Another example of Tony Fucile's animation draw-overs in the final battle.

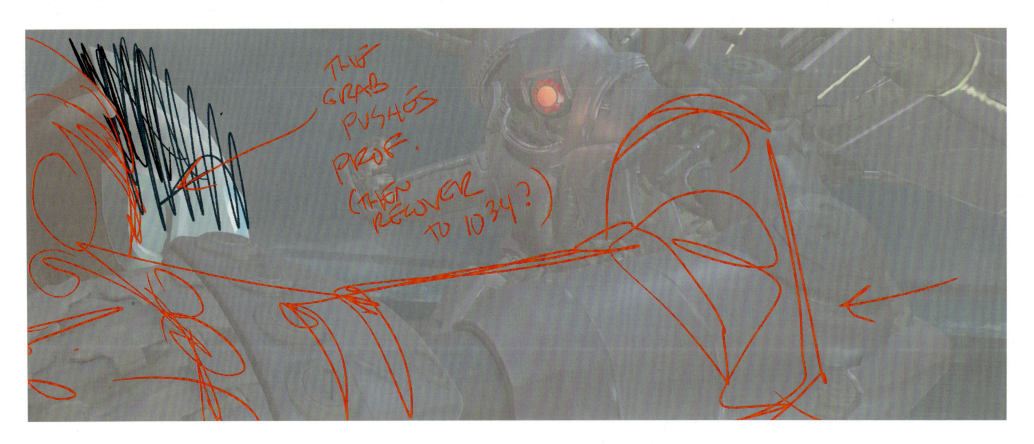

is that the lighting was very realistic, kind of like Gordon Willis-y in a way." Fucile said that in typical animated features there would be virtual lightbulbs all over the mouths of characters. It "makes the lip sync feel nice," Fucile said, even if it's not quite real. *Ultraman: Rising*, however, "feels more stylized and almost more like an animated thing. That was something that I had to adjust to, but I couldn't tell what the lighting was going to be," Fucile said.

Sometimes his sketches would be to dictate an "impact drawing," like a collision not quite working. He would do a quick sketch to demonstrate how that shape change might work. This is how he first learned how to animate, from masters like legendary Disney animators Glen Keane, Mike Gabriel, and Brad Bird.

"There's a million ways to do something. I've always felt like this. Even when I first started, it's like I could see an animator do something and I'm like, 'I wouldn't do that, but that's cool.' Or, 'I wouldn't make that choice, but I like that.' I got excited when I first started, about 1986, seeing what everyone brings," Fucile said. "That's kind of my mindset when I work on a film. I don't think, 'How would I do this?' And I'm going to enforce my style of what I want to see. I love working with the team, wherever they're taking it. I just want to help them along the way. It's more supportive and less obstructive."

Vig said that Fucile was always very careful not to make the already tenuous schedule even harder. He would never besiege them with crazy new ideas. "When the shot was almost finished, he was very, very considerate. We really just wanted to bring up little touches where they could be added without ruining an animator's shot, an animator's three weeks of work. And it really makes a difference," Vig said. "I think a shot can be really ruined by one wrong frame. You just see it. And I think he's that guy who will just see that frame, make a perfect drawing and the animators won't even have questions. Like, 'Yep, okay, this is the drawing that will save my shot.'"

Working with Fucile was, according to Vig, "a very cool collaboration." "You don't want too many cooks in the kitchen, but it was much more of a great support and quality-raising role that he had," Vig said.

Also helping the team was that Tindle was "the clearest director we ever had to work with." "We would never start any shot with a vague concept or, 'Let's try this,' or, 'Let's try that.' He would have a very, very clear idea of... the tone, the lighting, the mood of every single shot before we started it," Vig said.

Tindle "ruined it" for the animation team. "When I say ruined us, I mean that this is so different from the way we usually interact with the director. We never see the directors at ILM pretty much. Being able to spend these two years literally daily with a guy like Shannon, it's such a great learning experience and I think everybody really ups their game here because of the anecdotes, and the details, and the notes that he would give us day-to-day," Vig said. "It was never, 'I don't like it.' It was never, 'It doesn't really work.' It was always in a very positive way, 'The tone is not necessarily the right tone for the sequence. Make it a little bit more this way, a little bit more that way.' But very positive, just honestly an incredible experience as an animation supervisor but [also for the] animators as well. You can ask all of them."

There are always "production babies" on animated features — babies that are born during production, usually utilized to show just how long these movies take. But with Vig's young daughter exactly the right age as Emi in the movie, she is really *in* the movie. It makes the project mean even more to Vig. "I just watched her running with her arms out and her wobbly legs. And so I just took a video of that," Vig said. She's five now and he's showing her pieces of the movie and "trying to explain that this is you, this big, big monster is actually you. She doesn't really get it."

As for summing up his entire *Ultraman: Rising* experience, Vig said, "It was annoyingly smooth, and just pleasant and peaceful to do. It's really annoying that it's over now, I have to say." Let us manifest a sequel.

▼ Color key by Gabriel Gomez for Sequence 2800, "Ken Throws A Tantrum."

▲ Gabriel Gomez explored the look of Emi's ecolocation.

▼ Color key by Gabriel Gomez for Sequence 2100, "Before/After."

VOCAL PERFORMANCES

Ultraman: Rising's uniqueness translated to its voice cast. The team took a holistic approach to find the right performers for the right role.

"We had auditions for everybody and I didn't go in saying, 'I want this person, I want this person, I want this person,'" director Shannon Tindle said. "There were names that were presented to us, but it really was, 'Let's find the person who embodies this character.' And we did. Our cast is absolutely incredible. They brought amazing warmth and nuance to their roles and fleshed out their characters in ways I couldn't have imagined."

For co-director John Aoshima, the process of recording actors was a "learning experience" and one that he was grateful for. "I haven't directly worked with actors in a way where I would ask for specific performances. Shannon has more of that experience. And to be honest, at the very beginning, I wanted to know what that dynamic was going to be like," Aoshima said. "I quickly realized Shannon had already gone through a multitude of [ways] the characters should perform. He wrote the dialogue. If he's looking for specific nuances, he's already gone through that filter as he wrote. I came in a lot fresher."

Instead, Aoshima said, he would ask questions, gaining a different understanding of the script. He would use this new understanding while in the recording booth. "I tried to support Shannon's vision in a way where it's like, 'I know he's written it, but how is it communicating from the outside, like an audience perspective?'" Aoshima said. He also looked at cultural nuances that could be added. "It's not really dictating how it should be said, it's more like, 'Here are alternates.'"

Aoshima said the process was about "learning what was in Shannon's head and how he wanted the scene to play out once we had the real actors in there." It helped Aoshima on the visual side of the movie, since he felt like he was "matching" the intention of both Tindle and the vocal performance. A big part of this was conveying what Aoshima referred to as The *Ultraman* Spirit. This was a level of subtlety and meaning that Aoshima wanted to make sure was present, and something that he feels like the voice recordings helped him achieve. An example Aoshima gave was the moment when Professor Sato, the elder Ultraman, puts his hand on his wife's photo and says, "She taught me to be human." The meaning on the surface is that she taught him to be a better man, but the underlying meaning (and part of The *Ultraman* Spirit) is that he was actually an alien. "Professor Sato is explaining what the purpose of being Ultraman is to Ken," Aoshima said. "I think that resonates now."

▶ One of the film's stars, Christopher Sean, posed in front of members of the film's LA crew.

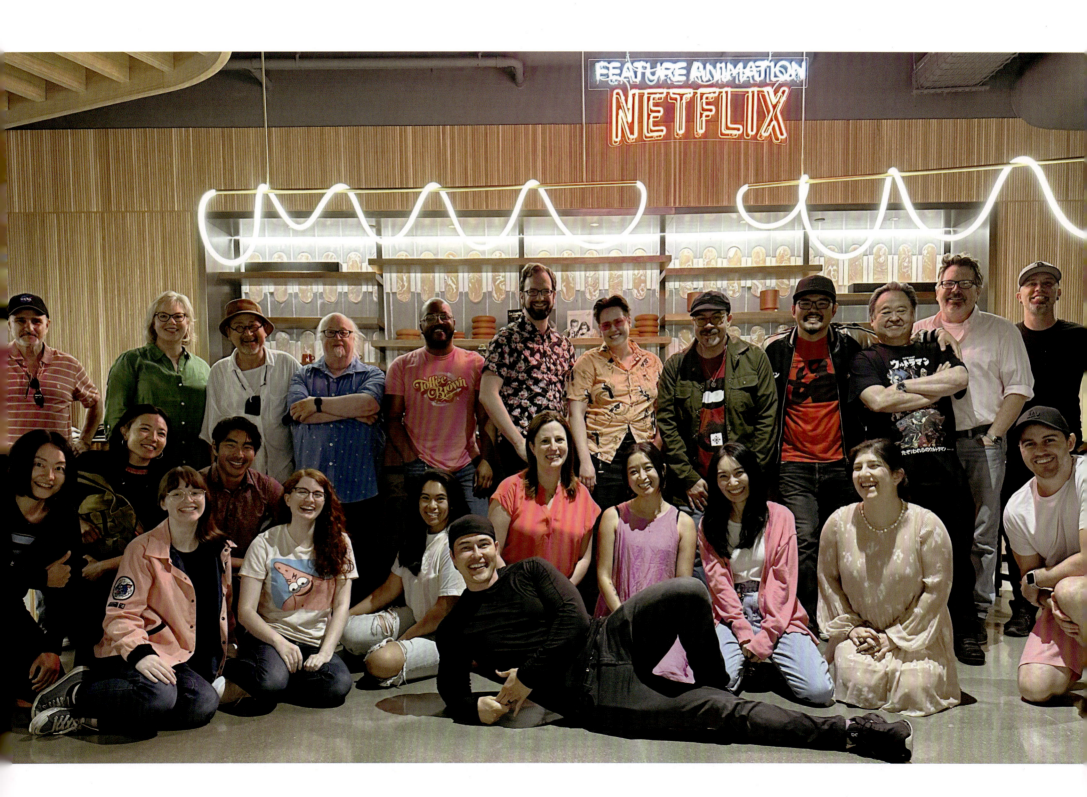

CHRISTOPHER SEAN AS KEN SATO

Christopher Sean's father was in the Navy. Sean lived in Japan for a period and would frequently visit his grandparents and cousins. When they attended local festivals, he often bought a mask – usually Ultraman or Ultraseven. "I always wanted Ultraseven," said Sean. It's easy to see why – Ultraseven's mask had a green gem in the middle of his forehead and a cool fin.

Having family in Japan gave Sean a cursory understanding of the character, but when he was cast as Ken Sato, this new generation's Ultraman, he started doing research. "That's when I started learning about *Ultraman*, the franchise, the *kaiju*, and so on," Sean said. He knew that Tindle and Aoshima wanted to "pay respect to Tsuburaya and everything they had created." "My goal was to never dishonor the franchise. They've created so much from 1966 on. Even today, they're still creating amazing new takes on Ultraman," Sean said.

He knew how special this new take was and felt connected to this version of the character. "Being mixed Japanese and mixed white, I do feel in many ways I'm an alien, because I don't fit in American culture. I'm not white enough to be white... I'm not Japanese enough to be Japanese," Sean said. Sean remembers being teased for bringing Japanese food to school for lunch and wanting to trade with the kids who brought peanut butter and jelly sandwiches. "I feel in many ways that Ken Sato has dealt with that in his life," Sean said. Sean's father was in the military and was deployed a lot. When his father was gone, Sean felt a mixture of missing him and being angry. "There's another relatability between Ken and myself," he said.

When his dad was deployed, he'd send recordings of himself reading books via VHS or beta tapes in the post. Sean would then watch his father on TV, and remembers thinking, 'Man, I want to be just like my dad.' His mother would record messages from the kids to their father in return. Sean would say, "Hey, Dad, I'm going to get big and strong just like you and I'm going to be on TV like you."

"That was my upbringing, but I was so shy," Sean said. "And when you see the footage of Ken growing up, I was like, 'This is so relatable. It's insane.' I feel like they just took parts of my life and spliced it together to make this movie."

Baseball was also a connection Sean found between himself and the character. The first movie he starred in was a baseball film. He's also appeared in 335 episodes of daytime soap opera *Days of Our Lives*, playing a baseball player... not that he's skilled at the game. "For a very long time in my career, I've been playing baseball players. And I'll be honest, I can't even hit the ball," Sean said. "I'm very athletic, but if the ball's coming at me, I'm terrified, I swing and I just miss."

Ken's character arc drew Sean to the role, as the character goes from a braggadocious baseball player to something softer and more relatable – not only a father, but also a better son to the father he felt had abandoned him. "Once he starts to learn to love himself, he's able to love genuinely, I feel," Sean said. "But you have to break those barriers. You have to deal with the issues from your past. Again, his father not being there... he has to face his father and start to understand a bit. Once you start to take off those band-aids, then you can start to heal. I feel that with Ken. It was a lot of self-discovery, and through that, he was able to then truly be the man he always wished that he could be. And the man his [parents] always saw in him."

Sean had done voiceover work before; he was a lead in the *Star Wars* animated series *Resistance* and appeared in a number of videogame projects, including *Gotham Knights*, where he got to portray the first Asian-American Nightwing. At one point, Sean thought that being a character in the *Star Wars* universe would be the apex of his career. "Now Ultraman is the apex," Sean said.

When talking about the experience of *Ultraman: Rising*, Sean defers from taking any real credit. "I love to dive into the realm of the psyche of a character, but as an actor doing voiceover, you have to have a lot of trust in the overall vision of the directors, of the team in the booth," Sean said. He credits "the entire team that's in that room" for taking and receiving ideas. It's his job, Sean says, to catch those ideas and "find a way to put my fingerprint on it and give it back to them." He always had to stay on his toes and try new things; for example, for the scene where he's eating noodles, he would stuff wads of tissue paper in his cheeks and then act out the scenes. "Nothing's taken away from me, so I still feel like it's my world. But again, it's all being molded by a collective. Having a great team really helped shape the character of Ken," Sean said.

When asked about what it's like bringing this new version of Ultraman to the world, Sean quoted Dave Filoni, a huge Ultraman fan and the creator of *Star Wars: Resistance* who is now shepherding live-action projects like *The Mandalorian* and *Ahsoka*. Filoni told him, "No matter what, don't worry about what the fans say. Do something you love. Put your heart into it. Be passionate. The right fans will come." Sean took his advice to heart. "I'm focused on putting my one-hundred percent into the project. I love this character. I love this movie so much," Sean said. "I feel more excited than the fans are to see it come to the world. So I'm not even worried about the negative. I'm only excited about those who are going to support and love it as well." You can feel the love talking to Sean and you can feel it in his performance. He knocked it out of the park.

▲▶ Final color and texture for Ken by Sunmin Inn, and his younger design by Keiko Murayama.

▲ Christopher Sean posing with Hiro Nakamura, who voiced young Kenji.

GEDDE WATANABE AS PROFESSOR SATO

"As a little kid I heard about [Ultraman]; I didn't know very much about him, but I remember seeing little snippets," actor Gedde Watanabe said about the original *Ultraman* television series. (He would have been around ten when the original series aired in America.) What he remembers most were the "really bad special effects," which, we know now, were cutting edge for the time and hugely influential to this day. "It was great though," Watanabe said. "They were kind of like Godzilla to me." He would eventually revisit the older episodes on YouTube, along with some of the newer incarnations of the character.

Watanabe is an actor you undoubtedly know. He played Long Duk Dong in John Hughes' directorial debut *Sixteen Candles*. It was only Watanabe's second movie part, as a grossly stereotypical exchange student. As his career progressed, Watanabe would go on to perform in memorable and more nuanced roles, in movies like Ron Howard's *Gung Ho* and Joe Dante's *Gremlins 2: The New Batch*; he would also memorably provide voice work in *Mulan* and its direct-to-video sequel. (His career is even more prolific on the small screen, where he would have a recurring role on *Sesame Street* for four years and on *ER* for six years, among many others. He even reprised his role from *Gung Ho* in a short-lived sitcom spinoff.) And yet it seems like everything Watanabe has done was leading to this role in *Ultraman: Rising*.

The first meeting for Watanabe was reassuring, in a way, because the filmmakers knew his work so well. But he admits he had "no idea" what the role would entail. This isn't unusual, he stresses, since sometimes he attends meetings to see what the project is and what everybody is about. "It took me a while to realize that this was a full-fledged character, to be honest with you," Watanabe said. The first meetings he described as "exciting."

He said that since it was animation and that he was recording in a vacuum, it was hard to get the whole story. "I would get tiny clues," Watanabe said. He described the recording sessions as him keeping "one eye on the page and one eye on the booth," to make sure that he was getting a good reaction on the other side of the glass.

Slowly, he would start to see actual animation. "And you see it and you go, 'Oh my God, this is really happening.' It's a process of constant surprise," Watanabe said.

His performance as Professor Sato is shot through with sadness; the character protects Earth from the *kaiju*, falls in love with a human woman, and has a son. He gets older. And injured. And his son has to take over the family business of saving the world. There's a lot of weariness to the vocal performance, not that Watanabe is ready to take any credit (though Tindle emphatically disagrees). "I think it is just the aging process that I'm going through right now," Watanabe said. He had just gone through hip replacement; he'll probably have to do another. His doctor said it was from the actor doing so many pratfalls on stage. Watanabe doesn't regret it. "I loved all that stuff, but it did wear and tear on me," he said.

The more emotional aspects of his character were surprising to him, though. "I didn't know where it was going. I was getting clues, my son and the regret that I had started getting clearer and clearer, and I thought, 'Wow, there's more to this than what meets the eye, more than just the bang ups and everything like that,'" Watanabe said. "The relationship came through, so I was really appreciative of that. That doesn't happen to me very often." Again: his career is sometimes, falsely, defined by the caricatures that he was forced to portray. But even then, they had soul.

"I just showed up. Both Shannon and John knew what they wanted, and I didn't have to do very much," Watanabe said of the process. "I was just appreciative. They embraced what I was giving them."

Tindle disagrees. "Gedde brought a tenderness to the character I wasn't expecting. I knew I didn't want him to be the stereotypical stern father, but he really elevated the character."

One surprise from the script that Watanabe really embraced was the reveal that his character still had powers; in the final moments of the film Ultradad reveals himself. Mustache and all. "At one point, it was a little kind of nerve wracking, but at the same time, it was really exciting," Watanabe said. He couldn't believe we were even talking about it now.

Watanabe has done a ton of voiceover work, with *Mulan* being the tip of the iceberg, having contributed to *Rugrats, The Proud Family, Kim Possible, Family Guy*, and *Batman Beyond* (among others). But he asserts that *Ultraman: Rising* was different and very special. "Well, this, I think, is the first time I am not so much on the periphery. He was a full character, and it was a father and a son. And how often do you get an opportunity to play that type of situation? Maybe I do it in plays, but not in films or anything like that," Watanabe said. "It was a good step for me to have that and to feel how to feel it in an animation mode to make it real. Also, because connecting to animation, at first, you think it's a big hurdle, but after a while it just comes out, I guess."

When he was first shown his character, he said that he was "stunned." "I teared up a little bit. I just sat there and said, 'Oh my god. This is what you guys were doing?' And I think they saw that in my face. They saw that I was just blown away," Watanabe said.

While he can be a bit self-deprecating (he says he's the opposite of looking on the brighter side of life), Watanabe does understand how exciting and important it is to be in a project like *Ultraman: Rising*. "It's just going through the process of just taking the ride. That's all you can do really at this moment," Watanabe said. "Just see where it goes and see how they embrace it and everything like that."

Still, even someone as prone to cynicism as Watanabe sees a future for his character. "Hopefully they do *Ultraman 2*. That would be fun," Watanabe said. Yes it would.

▲ Professor Sato at the end of the film, as he sails toward *Kaiju* Island with Ken, Emi, and Gigantron.

▲ Gedde Watanabe was always a joy to watch in the booth.

KEONE YOUNG AS DR. ONDA

If you want a memorable villain, it's probably good to cast a memorable performer. And that's exactly what the *Ultraman: Rising* team did when they chose Keone Young to portray Dr. Onda, the morally conflicted head of the science team responsible for chasing down *kaiju*. Young has been in so many films and television shows, everything from *The Brady Bunch Movie* to *Honeymoon in Vegas* to *Mulan II* (where he co-starred with Watanabe) to appearances on episodes of *Cheers, 21 Jump Street, MacGyver, The Golden Girls, Star Trek: Deep Space Nine,* and *The Simpsons*. And this is the tip of the veritable iceberg of his career.

Young remembers *Ultraman* airing when he was in his teens. At the time, he remembers going through a "neorealism" phase, as did much of the country. He was reading Hemingway and Steinbeck, and the plays of Tennessee Williams and Arthur Miller. "I was not into hero-worshiping. I was more into the anti-hero. My hero was Marlon Brando," said Young. This was perfect, in fact, for his take on Dr. Onda. "I saw my character in that kind of mode too. In terms of Dr. Onda, he's the villain, but he, to me, had that same kind of structure as being an anti-hero," Young said.

When Tindle and Aoshima gave Young the "basic idea" of the character, Young said he could "identify with it personally." "When we go through contradiction and conflict, one thing [that] comes out of that is a look at oneself. You hear criticism from other people, you criticize yourself, and you try to come up with some kind of solution. I don't know if that makes sense to you, but I think that the character itself was complex with many contradictions, and he is trying to resolve it in some way," Young said. "But this moment in his life of losing his family is so overpowering that he cannot resolve it. He cannot resolve this concept within himself, this contradiction, and I think it becomes twisted like most individuals in this world."

He connects this sensation to a number of characters. Young reminded me that he was the original Storm Shadow from *G.I. Joe* and even that character had this sea of emotion roiling within him. "Every character that I've done, I don't care if it was from *Avatar: The Last Airbender,* or Commander Jun Sato from *Star Wars Rebels*, I always bring myself: my conflict, and my dreams, and my passion, and how it's been denied, what do they call it? A dream deferred," Young said. "That's how I related to it. I always brought that to my characters no matter what."

On the hit show *Deadwood*, he fought to make his character more than just a villain, but rather "an individual with dreams." "When we're born, we are pure and we have these aspirations, and then life gets in the way," Young said. With Dr. Onda, he thought that he could "identify with that in the same way." "He probably had some great dreams and wanted to be a scientist, but he lost his family. I guess how he dealt with it was the way he tried to resolve that conflict in himself. I'm sorry that he took the wrong path," Young said. "But whether he took the wrong path or not, he gave up his life for it."

Dr. Onda is definitely in conflict – *kaiju* were responsible for the death of his family. It led him on a quest for revenge; eventually he does away with his humanity almost completely and gets inside a giant robot to kill off not only the *kaiju* but Ultraman himself (whom he sees as complicit). And Onda in a giant robot is fun, but, as always, Young was searching for more. "I always try and bring something deeper, try to reach the audience in terms of more humanity, question people's personal identity and what they feel about themselves and their life," Young said. "I know people love bigger-than-life characters. But at the same time, I always want to reach out to individuals and make them think, what about me? How would I deal with it if I was in this situation?"

Young said that Tindle and Aoshima talked to him about Dr. Onda and how his presence subverts a lot of *Ultraman* lore, since the science team is typically a force for good and oftentimes Ultraman, in his human form, is working with the science team. This explanation was part of the ongoing relationship between the performer and the filmmaker, a relationship that Young cherished. "I have to say that working with Shannon and John as a team was wonderful because they were open and receptive to whatever I brought to the table," Young said, mirroring the sentiment of pretty much everyone who worked on the movie. "It was a collaborative effort that I felt was kind of seamless in the sense that we were open to ideas and we never had a conflict. They were always supportive and always understood what I was trying to do, and I understood what they were trying to do. It was a wonderful experience because we just threw around ideas and we tried different things. I was very happy."

He said that they were experienced enough to know to let the performer go ahead and do his thing, combing through the material to find positive aspects that Young contributed. "I think that I'm experienced enough, and they are as well, that we can see gold through all the dirt and all the stones, and pluck out which ones are of value," Young said.

Was Young blown away when he finally saw the movie?

Well, no. But that's just the way that he is.

"I look at the organic value of myself, my contribution, and the thing as a whole. I find results amazing that somebody can put some words to a piece of paper and from two dimensions, make it into three dimensions, put it up on screen with voices and color and drawings, and then bring it to a fourth dimension to where it's not only something physical, but something also spiritual. I find that amazing always," Young said. However, "I'm not going to tell you, 'Oh wow, it was great. It was wonderful.' I want to know what people think."

In terms of bringing Ultraman to an even wider audience, Young has some thoughts on that too. "I grew up in the time of post-War where everything Japanese was bad. If a product was terrible, they would say that it was probably made in Japan," Young said. "Characters that were portrayed on the screen were always the enemy. Our time has changed because of struggle." Young cites Bruce Lee as an "icon in terms of not only as a hero but someone who changed people's views about us." "*Ultraman* does the same thing," Young said.

Young continued: "I believe it's the creators like Shannon and John who have fully respected the art or the presentation to give it that kind of respect. We're going to do it in English and give to the American people a part of culture that they might not know of. In that sense, I'm very proud. I'm very proud that this was an Asian-American piece, a Japanese-American piece, and it's being delivered back to Japan saying, 'Hey, we did it. We did it. This is our thing. It was your thing, and now we're giving it back to you.' And they are now dubbing it into Japanese! It blows my mind that Ultraman is in English being dubbed into Japanese. I use my full expression as an American as the character. Whatever that means to you, and it means a specific thing to me. It resonates with me and my people. And I think as Americans, we can be proud of it."

▶ Color key by Nacho Molina for Sequence 4400, "Cocoon."

▶ Opposite page: Keone Young paused a busy day of recording for a picture.

TAMLYN TOMITA AS EMIKO/MINA

Tamlyn Tomita, who voices Ken Sato's mom Emiko, as well as his robotic personal assistant Mina, is a second generation Japanese American and said that she "grew up with *Ultraman*," although at the time she remembers "not being able to watch it as easily and conveniently as we can nowadays." It was something she would have to search for. While there was a large Japanese American community in Los Angeles, where she grew up, she doesn't think it aired regularly. She does remember seeing comic books depicting the character, but they were all in Japanese. "And I can't read Japanese, never could," Tomita said. She saw characters in the comic books that "looked like me," which she found extremely empowering. "It's very foundational," Tomita said.

She said that, through the years, she could trace the influence of Ultraman, whether it was in *Power Rangers* or *Transformers*, even in *The Iron Giant*. "You see that evolution as to how a big metal being can have humanistic qualities, and it was something that's magnificent," Tomita said.

Tomita remembers the audition process for *Ultraman: Rising* being fairly typical – they asked for her to send a voice recording of a particular scene, which they responded well to and invited her to be a part of the movie. Unlike some of the other actors on the project, Tomita said that she doesn't have a huge resume when it comes to voiceover roles. She figured it would be a "supporting dinky role" so she was shocked when she learned that she would be the wife of one Ultraman and mother to the new Ultraman. "It was just wonderful to be a part of this *Ultraman* community," Tomita said. She remembers that at one point they said, "Oh by the way, you're going to be playing the little AI companion to Ultraman." She wasn't totally sure what they were talking about but imagined that it would be like Navi, the little navigator that assists Link in the *Zelda* videogames – a guide to assist Ken on his journey.

According to Tomita, the robot character, eventually named Mina, was initially called Mother, making the connection to Ken's mother even more explicit. (The name would also have connected *Ultraman: Rising* to another beloved sci-fi franchise, as the computer in Ridley Scott's *Alien* is called Mother.) "There was some confusion and kerfuffle, but ultimately it just became Mina. It's less confusing. But I think, and I hope, and I pray that the audience can see that it is truly the spirit of Kenji's mother there," Tomita said.

This being her first voiceover experience, Tomita said, "I don't mean to be crass... It's your virgin experience. You'll always remember it. It's very special." She would take her glasses off in the booth, because she just wanted to be free physically and to "know the lines and have it live in me." She couldn't see the expression on the filmmakers' faces. But she knew they were there – her "incredibly collaborative, enthusiastic cheerleading squad." "As an actor, it feels a little bit separated because you don't see the character and everything lives in your head," Tomita said. But she knew there were bumper lanes set up by the filmmakers. And every time she "got a strike," she would know.

She approached Emiko differently than Mina and appreciated the filmmakers "for recognizing the difference between a Japanese woman and a Japanese American woman." "Being an American, you straddle the coolness about being an American who's lucky enough to know where they come from, and to preserve cultures, cultural and ethnic heritages, and traditions. So Emiko came in as this super western American mom with sensibilities of being a Japanese mom as well," Tomita said. "Her heart was unfiltered. She was excitable, she was noisy. She was annoyingly enthusiastic about her beloved son and I think she imbued that sense of joy and love. Not saying that it's not Japanese, but it's a much more easily and unfiltered expression of that kind of joy. Emiko was that."

On the other hand, Mina had "that sense of motherliness, but much more tempered down." "Shannon and John were able to say, 'Let's see a little bit more sparkle,'" Tomita said. She brought her volume and register down. And she also slowed down the speed at which she delivered the lines; Emiko is much more excitable, Mina is much more measured.

While a planned animated series was meant to provide some of Emiko's backstory, Tindle and Aoshima told her everything that she needed to know – that she was a "badass," the founder of the KDF science team who was interested in preserving and protecting the *kaiju*. (An alternate ending saw her living on *Kaiju* Island, a kind of Jane Goodall for the orphaned baby *kaiju*.) "It's just that your son doesn't know how much of a badass you are. And it's like that's gold for an actor. There's a secret. There's a secret that you hold and you play with, and it filters out organically, but you don't say anything to that fact, and it just lives and breathes in the air," Tomita said.

She also plays a woman that married an alien, another fascinating aspect of the character. "We've got a lot of work to do, not only as Americans, but as earthlings. Can you imagine when we expand out, generations from now, as part of this Milky Way galaxy and part of the universe?" Tomita said. "There's something godlike about the energy, and that energy feeds, gives, sustains life. And I think that's what Emiko saw so many years ago, she felt that without knowing it. And she fell in love with that. She connected with something that's so organic and infinite. And if we each can individually... and collectively plug into that, I think we'll be alright. I think that is the bottom line of this *Ultraman* story."

And how does she feel about being a shepherd of this story (and of Ultraman), now reaching out to a global audience?

"I think with all stories, we're all trying to find some kind of connection. Why would I want to be a part of this story? Why would you want to be watching this story? And it's just trying to find those threads. If you're going to stream it at home, the audience members are going to invest time into this story. And I think what Shannon, and John, and Bret, and the whole *Ultraman: Rising* team did with the source material is that we're all one family," Tomita said. "And it's, again, it's a point in history. It is an emotional breaking point, but our spirits, our energy fields, our souls continue on forever. And as long as we can circle back, we can always feel like we're a part of the same family. And I think that's what we are trying to aspire to. We reach the older OG generations of *Ultraman* fanatics out there, but also persons who have no idea what this, since 1966, has meant to not only Japanese fans, but fans around the world, and also a new breed of people who want to just watch new content, new stories, the best animation. It's really sexy because it's just so dynamic. It's speedy, it's fast, it's fleeting [and] of-the-moment. I think, too, it speaks to a whole plethora, a whole spectrum of people. And it's just about we are all one."

We are all one. And we are all Ultraman.

▶▲ Minako Tomigahara's adapted design of Emiko wearing Dodgers gear, and Gabriel Gomez's final color and texture paint pass for Mina.

▶ Opposite page: Tamlyn Tomita posed with Aoshima and Tindle.

JULIA HARRIMAN AS AMI

Like some of the other performers cast in *Ultraman: Rising*, Julia Harriman did not have an encyclopedic knowledge of the character or the overall *Ultraman* mythology. "I knew about *Ultraman*. I had a lot of uncles and cousins that grew up watching. My brother also knew what it was," Harriman said. "Of course, after auditioning and then getting to be a part of this, I did my research." And her family's reaction? "They were stoked. They were so excited," Harriman said.

Not that Harriman even knew she was auditioning for an *Ultraman* project.

She met director Shannon Tindle and co-director John Aoshima during her callback. They were talking about scenes but weren't specific on what the movie was. Instead, they talked about who Ami was as a character and how she would change through the course of the movie. "She is a determined reporter trying to get to the bottom of everything. I wouldn't say that she starts to figure things out, but she is definitely like, 'What is going on here? This is strange,'" Harriman said. "She's also a mother, and so you see that nurturing side of her, which comes in handy later. And yeah, she helps out her friend." This happened over the first Zoom she had with Shannon. She also got to see a rough sketch of her character.

The cast had a table read and then, when she got into the studio, she got to talk to Tindle about "who she is as a character, and what she does for the show, and how she shines." The recording process is somewhat difficult, Harriman said, because you would be so intensely focused on the scenes for that day, without discussing or even knowing the larger context. "The whole scope of everything wasn't necessarily what we got from the beginning," Harriman said. Instead, she would be told "this is where we're at right now, and this is what you need to know, and this is what's going on."

Of course, as the process went along, not only did she understand that she was in a bold reinvention of *Ultraman*, but she also got to record with Christopher Sean. "It was really fun to play off of each other, and I learned so much just from being able to watch and witness someone else doing this," Harriman said. She had never done voicework for an animated feature before. "Getting to watch him do everything and then getting to interact with that, it made my process go so much quicker. But it was also just so much fun to play off of that," Harriman said. She was used to having scene partners. Not that screaming and yelling in the booth wasn't also delightful. "I had the most fun doing that kind of stuff because you really just get to be crazy," Harriman said.

Working with Tindle, Harriman said, was a delight. "It was like working with a friend that I'd known for a very long time. It was so much fun, and I got such great feedback, but also just the wisdom that was pouring from him," Harriman said. "That experience was fantastic. And honestly, I couldn't have dreamt of a better first-time [voice acting] gig than this. It was really a dream come true." Aoshima would often join Tindle, which impressed her even more. She said the pair would give her feedback and she would be dazzled by their knowledge and "what they put into this thing and how they could see the whole thing." "Everything was so clear," Harriman said. "And just getting to work with John as well... They knew exactly what it was that they were getting, which made everyone's job so much easier."

When asked if there was anything she wanted to add about her *Ultraman: Rising* experience, Harriman quickly replied, "I think the biggest takeaway from the whole thing was how comfortable everybody made me feel and how kind everybody was. And again, jumping into something like this, not ever having done this specifically on a movie, it was really such a beautiful and a heartwarming scenario to be in. I feel like every single person had my back. Everyone was there to show me the ropes and there was no judgment in anything. You can look pretty crazy doing these things, or just standing there and running in place and breathing and screaming, and no one makes you feel out of place. No one makes you feel stupid. It was just... I could not have asked for a better introduction to the [voice acting] world."

From Tindle's perspective, "I want great actors. Voice acting experience isn't required. Julia brought so much to the role that her experience voicing animator characters was never a question."

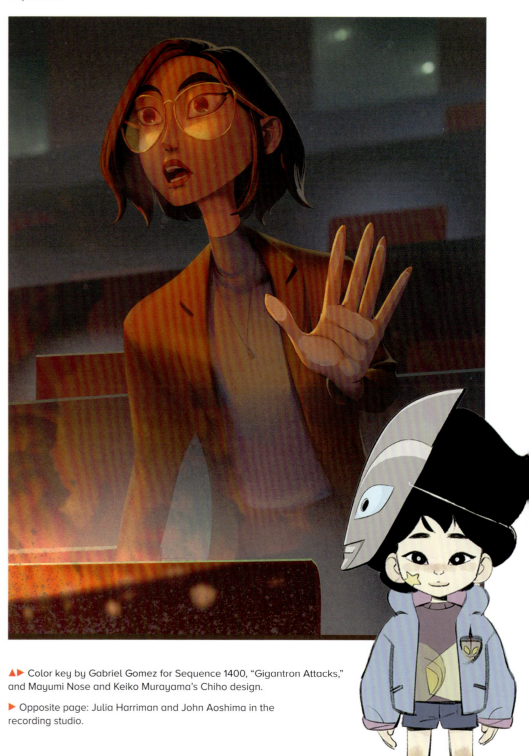

▲▶ Color key by Gabriel Gomez for Sequence 1400, "Gigantron Attacks," and Mayumi Nose and Keiko Murayama's Chiho design.

▶ Opposite page: Julia Harriman and John Aoshima in the recording studio.

▲ Editorial's stacked Avid timeline for Sequence 0300, "Meet Ultraman."

EDITING

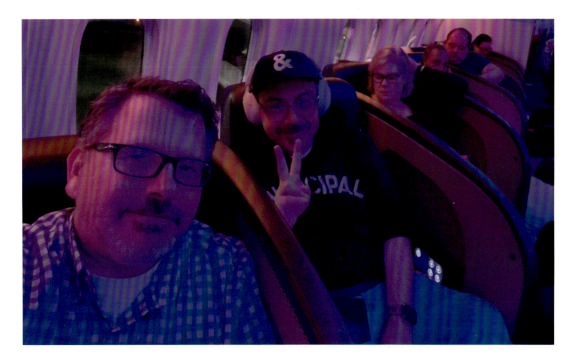

Bret Marnell and Daniel Evans both worked at Sony Pictures Animation on *Spider-Man: Into the Spider-Verse*. At the time Tindle was developing *Made in Japan*, Marnell had just finished work on *Smurfs: The Lost Village* and the studio had been so happy with his work that they assigned him a "bridge position," where he was working with four different directors on four different projects as they were moving along into production. One of those projects was *Made in Japan*. After working together for a little while, Tindle proposed that Marnell work on *Made in Japan* full time.

"I remember he said to me like, 'Hey, do you want to start working just on this exclusively and stop sharing time with all those other projects?' And I was like, 'Yes, yes, please,'" Marnell said.

"We hit it off immediately," Tindle said. "He's such a detail guy. He's really, really thoughtful and I love that. And you want supervisors who you can trust when you're away, to understand what the movie is about and to carry that throughout. He's always there trying to make the film better and trying to push other people to make it better."

▲ Bret Marnell and Shannon Tindle were all smiles on their way to London for the film's scoring. Behind them, Lisa Poole must be answering one of her many emails.

When *Made in Japan* fell apart at Sony, Marnell worked on something else for a year. He helped Tindle out on an initial test for *Lost Ollie*, his Netflix series that preceded *Ultraman: Rising*. But when Tindle told him that *Made in Japan* was back, now as an *Ultraman* project, Marnell was shocked. "I was so happy. And it was hard to even believe that it had emerged for a second chance," Marnell said.

Incredibly, like so many other people on the production, Marnell had lived in Japan as a child. That Japanese culture "came back with me when my family moved back to California," Marnell said. He and his older brother were obsessed with Japanese *Tokusatsu* films.

Evans joined the *Ultraman: Rising* team after the film's first screening. However, unlike Marnell, he had no knowledge of the history of the character. "I had to Google who Ultraman was, what he did, and the history behind it all. I had no idea,"

Evans said. But, as we've said before, a lack of awareness of the character was often incredibly helpful.

As the production supervisor for the editorial, Evans helped to organize the team's way of working. "It wasn't a streamlined process," Evans said. "I came in and said, 'Okay, here's what our daily goals are.' I broke it all down to: every day we're going to meet and we're going to talk about these four or five things and outgoing expectations, the dailies, reviews, priorities, and make sure we're all on the same page. If there was anything we needed, other people knew; if there's anything that people needed from us, we knew and we were able to tackle all those things. If there were any hiccups, any problems, I can raise those to Maddie, raise those to the producers. I tried to kind of streamline that down – what was needed of us and from us and go from there."

▼ Ken having a hard first time as Ultraman, with spectators watching as Neronga kicks his butt.

The process with ILM was also streamlined. They would get shots from ILM with a note saying that they would have to go over these shots with ILM in thirty-six hours. "So we had thirty-six hours in editorial to cut it in, confirm their lengths, make sure it all worked, cut in as expected, get them in front of the directors, get their responses and notes," Evans said. "So by the time we met with ILM, we had editorial notes and director's notes aligned. When we got to ILM, they knew everything that we needed to discuss with them. Our meetings with them were very much like, 'We've discussed all this, we need this, this, this, and we're good. Done. Moving on.'" Evans said they moved "quickly and smoothly" throughout production.

Marnell, on the other hand, was able to dive into the details of the film. He refamiliarized himself with the original *Ultraman* series. "I felt like I needed to have a better understanding of some of it, but some of the basics of it, yes, I knew," Marnell said. Early in the project, he would take sound effects from the old *Ultraman* shows and use them while assembling the storyboards into reels. He would include everything from the sound of his beam to the iconic echo of his transformation. Even though those effects were forty or fifty years old, they still worked. And during production the editing team would confer with Skywalker Sound, who created new versions of the classic sound effects.

In addition to audio, Marnell borrowed clips from the original *Ultraman* series to guide the action in this new movie. There is a moment when the Baby and Ken are watching television and Marnell chose a clip from the *Ultraman* series to feature on the TV. However, the clip involved Ultraman splitting a *kaiju* in half "and his innards are basically falling out." Tindle and Aoshima laughed. Unsurprisingly, the producers told Marnell, "Yeah, that's probably a little too much."

Another beloved element the team had to figure out was where to place the moment when Ultraman transforms towards the camera, an unforgettable, slightly jittery motion that is so emblematic of the original series. "When it came time to do that, I mean, I really was looking at how they did that transformation frame by frame in the TV show and did a very faithful recreation because we wanted it to feel right," Marnell said. "At the same time, we also were trying to make a movie that was for everybody, and we didn't want to feel totally bound into some of the rules of the *Ultraman* universe, some of the things that they had done in the TV shows or some of the things that they hadn't done." That push-and-pull — between paying respect to what came before and wanting to make something easily accessible and fun for the widest possible audience — was something felt in all departments, including editorial.

How successful they were at making an *Ultraman* movie for everyone was revealed at the movie's very first test screening, in Arizona. It was a theater of 400 people, pulled off the street.

"It's very nerve-racking. You have no idea. And we're showing a movie that's unfinished with black and white storyboards in it and other various phases of the production," Marnell said. "A good chunk

▶ Color script thumbnail by Sunmin Inn for Sequence 4700, "Return of Ultraman."

of it looked finished. None of it was done. It didn't have any of Skywalker Sound's work in it. It was all just our temp sound effects. It had maybe only one or two cues that [composer] Scot Stafford had written. It was mostly music from other movies. And you have no idea what the reaction is going to be."

As the screening progressed, Marnell could hear what was working. He could tell that people were engaged. At the focus group after the screening, he would hear parents say that they accompanied their children to the screening because kids love superheroes, but it was the parents who really engaged. He heard one parent say that they cried. "These are parents that just had come in with some knowledge that it was a *kaiju* movie or it was a superhero movie, but they weren't fans. And we heard numerous people saying how it had really affected them because of the family story, because it's a movie about parents and kids, and every one of us was a kid," Marnell said. "Everybody doesn't get to be a parent, but everyone gets to be a child and knows about that experience, and everyone in this movie is in those roles."

It was after this exciting first screening that Evans joined the team. And he was nervous. "Editorial in general is very hard... because it usually is the bottleneck of production," Evans said. There are usually several versions of the project (perhaps each addressing specific notes), and those versions are sorted out in editorial. He knew that it was a big movie, made by a big streamer. Plus it was a new pipeline and made largely during COVID. It used programs that Evans had never tried before. It could have been bad. But it was not. "In the end, the whole movie was the easiest process I've ever worked on. It was the easiest movie for me to work in editorial, where I was starting my day at nine and finishing at seven, and I never had that before. Especially editorial. I was always starting at eight, leaving at eight, stress throughout the entire day, never taking a lunch break. I was like, 'I'm taking a lunch break every day,'" Evans

▼ Color script thumbnail by Sunmin Inn for Sequence 4700, "Return of Ultraman."

said. "And I have never done that before, and that was so bizarre. This entire movie, I expected it to be very difficult because I know how difficult editorial can be and it ended up being a very painless, enjoyable process throughout the entire thing."

However, this isn't to say there weren't ever issues to work through. One plot point which needed work was Ken's transformation. Ken starts off the movie as an arrogant jerk; this makes his transformation to doting father and committed teammate even more powerful. It's also a template that has worked, time and time again, perhaps most successfully with something like *Iron Man*. While the movie got amazingly great test scores ("Maybe the best scores I ever got on any movie that I worked on," Marnell admitted), there were some comments about how off-putting Ken was towards the beginning of the movie. Everyone loved the journey he went on, but there were comments about his attitude towards the start of the movie.

This set off alarm bells at Netflix.

"We heard from Netflix after the fact that [they were] scared that people sitting at home in those first few minutes might think, 'Oh, this movie is about an arrogant jerk,' and *boop*, press the button, and stop watching, and go onto something else," Marnell said. "And I thought about it and I said, 'This never happens in a theatrical film because people make the choice to buy the ticket and go see the film. They sit down and, unless that movie is straight up garbage, they're going to give it a chance and they're going to get to see the growth of the character.' What Netflix asked us to do was go in there and change Ken's attitude a little bit at the beginning to make him a little bit more likable. They understood he still had to do this journey, so he couldn't just be a super nice guy at the beginning, but we changed out a few lines of dialogue and changed a few snarky comments to a little bit nicer ones."

Tindle bristled at this. "I hate it because it's a silly note. He's not very likable at the beginning. That's intentional. He doesn't have to be likable. He just has to be interesting," Tindle said. He pointed to Marty McFly, the character played by Michael J. Fox in *Back to the Future*, as a character who is not particularly likable. "He's kind of a punk and that's a big family movie," Tindle said. He also referred to virtually every Adam Sandler character – not likable, but interesting.

"To me, the argument was always, if he's more broken at the beginning, he has a greater, more satisfying journey when he travels from selfishness to selflessness, which is what you have to do as a parent. He needed to be selfish," Tindle said. While Netflix asked them to soften his character, Tindle still fought hard to protect this idea, giving real world sporting examples like Michael Jordan – a man who wants to win, without caring what anybody thinks of him. And he is one of the most beloved, most celebrated athletes of all time. "That was the constant argument that I would give is we have examples in the real world of somebody who is beloved, even though they can be abrasive at times," Tindle said. He is quick to point out that Ken still has "an edge to him," but that he "could have leaned in more and wanted to lean in more."

Tindle points to a scene early in the movie, when Coach Shimura is

talking to Ken. Originally, Ken got in Shimura's face. Instead, Tindle and the team chose to play it in a different direction, with Ken choosing the angle of, 'Look, I know you've had a tough year. Let me save you.' "It's still ego driven. It's still, 'I can save you,' but he's trying to help. You can have both. And I think because I was challenged on it a couple of times, it caused me to seek more complex solutions and deepen Ken, and I'm really happy for it," Tindle said.

For Marnell, what made *Ultraman: Rising* an interesting challenge was how many different tones and styles the movie contained. "It's a different kind of animated film in that it's not just a straight up comedy and it's not just a superhero movie," Marnell said. He said that in some ways the big action sequences were easier to edit; not only did they have the old television series to look at but also the way modern action movies are put together. This film was expertly pre-visualized, with Marnell, Bermudes, Tindle, Aoshima, and the rest of the team working out where the camera should go for the biggest impact. The quieter, more domestic scenes were what Marnell really sunk his teeth into.

"For me, the most interesting parts to cut in this movie were the parts where Ken was discovering what it was like to take care of a baby *kaiju*, what it was like for him to have a conversation on the phone with Ami about how do you juggle everything in your life," Marnell said. "Editorially for me, those moments, [such as] Ken and his father confronting each other at the door, having a difficult discussion about having felt abandoned, and of course Ken's dad, Professor Sato was like, 'That is the farthest thing from the truth. Everything I ever did I did for you.' While you look at the movie and you see these big giant cool battles and you see the super awesome impact of the punch that explodes in manga-esque artwork, those are actually sometimes the easier things to do."

Ultraman: Rising changed Evans' life. He said that he tells people that every movie will be compared to the experience of this movie, especially because he went through a personal struggle during production.

"My team was like, 'Don't worry about it. We're fine. Take care of whatever you need to do.' Netflix has great insurance. I didn't have to take any time off. It was like, 'everything was paid for.' It was fine. And it was like the family aspect of that movie, even really early on – they came

◄ Ken faces off with Shimura at the beginning of the film.

over me, and protected me, and protected the department," Evans said. The attitude reached from the very top to the very bottom of the production, which he found so encouraging and supportive. "I know that if something happens, it's going to be okay. Not only am I going to be okay, but the show is going to be okay."

The open honesty and communication didn't end with the personally-supportive side of the team. Evans discussed how after every screening they would have a "postmortem" analyzing what worked, what didn't, and how they could fix any issues. "That open honesty was so, so helpful, and I want to bring that to every project I do now. It's like every team I go to, how can I make this team as close to *Ultraman* as possible? You can't copy and paste every movie, but there are elements that I can take and see what I can implement into that project."

Like he said, *Ultraman: Rising* changed his life.

◀▼ Color script thumbnails by Sunmin Inn and lighting script thumbnail by Marcos Mateu-Mestre for Sequence 2900, "Call from Ami."

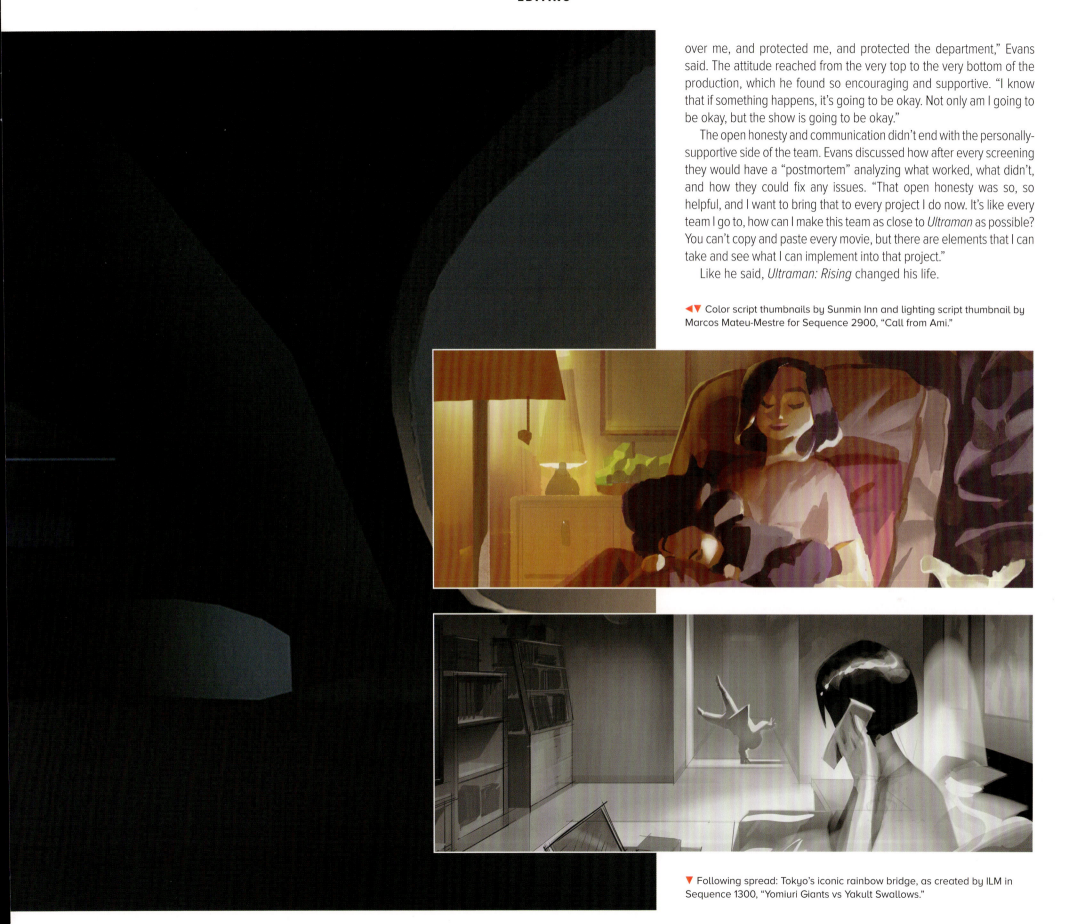

▼ Following spread: Tokyo's iconic rainbow bridge, as created by ILM in Sequence 1300, "Yomiuri Giants vs Yakult Swallows."

POST-PRODUCTION

▲ A world-class group of musicians gathered at
London's AIR Studios to record the film's score.

THE
SCORE

 Composer Scot Stafford remembers *Ultraman* playing on local TV stations at strange hours, back when he was a kid in the late 1970s and early 1980s. As a child he became obsessed with *Ultraman*. "I remember I went at least one Halloween dressed as Ultraman," Stafford said. "I can remember the plastic mask and the feeling of the really thin rubber band as it snapped against the back of my head and the tiny little mouth."

In the years since his childhood he had visited Japan several times and realized how big it is there, with toy stores devoting just as much real estate – if not more – to Ultraman as they were to properties from DC and Marvel. "I started to become more aware of it," Stafford said. He also became aware of its impact when director Shannon Tindle started talking to him about a script called *Made in Japan*. Stafford had only seen a first draft of it. Years later, he would be called to Netflix. The project was revived, only this time it was an *Ultraman* movie.

▲ Scot Stafford and Stephen Spies talked shop behind the scenes.

Stafford was one of the first people on the project; he remembers Shannon, Tom Knott, John Aoshima, Makiko Wakita, and Lisa Poole being about the only people there at the time. "I think I was number five or six in terms of people brought into the inner circle, which is incredible as a composer because so often you get pulled in as number 500," Stafford said. "It's sort of at the end of the process."

Poole remembers that there was some reluctance to bring in Stafford, even though he has worked as a composer, musical director, and creative director on projects for Disney, Pixar, and indeed Tindle himself, as the Emmy-winning composer on the Netflix series *Lost Ollie*. There was talk of bringing in a more "name" composer, but Tindle wouldn't budge. "They basically agreed to it because I insisted on it," Tindle said. "I've learned that fighting for people you believe in is a fight worth having. Luckily, when the team heard Scot's early themes, they were onboard, and became huge supporters."

What Tindle loved about Stafford's work was his voluminous knowledge of all kinds of different music and his openness to collaboration. In the years since they started working together, ten years ago (on the aforementioned Google Spotlight short), Stafford has become one of Tindle's closest friends and most trusted collaborators. "He always comes with great ideas. He always is thinking about story and character, and I don't know anybody who's better at handling notes," Tindle said. "I have an aversion to notes coming from certain people, but Scot always knows how to handle it. I wish I were more like him in that way where he's like, 'Okay, I know what to do.'" And for *Ultraman: Rising*, Tindle had a very specific set of notes.

The initial pitch from Tindle for the music was a big orchestral score, combined with 8-bit videogame music. Stafford obliged. And proceeded to build a synthesizer out of actual vintage game consoles, like the original Nintendo Entertainment System and the Commodore 64. He wanted to eschew the use of AI or any kind of simulation of classic 8-bit music, known for its chippy, upbeat, utterly infectious sound. "I wanted to do it right," Stafford said, as he hoisted an original Nintendo game console with a funny cord sticking out of it that he explained was a MIDI cable (which stands for musical instrument digital interface). "I hacked my way into a Nintendo and basically turned it into an outboard synthesizer that I could program my own music into," Stafford said. Simple enough.

Other elements were also a part of the *Ultraman: Rising* musical bouillabaisse, including cues from the original *Ultraman* series. Early in the movie, Ken mocks the theme music. But when the classic transformation happens later in the film, they bring it back. "Scot did his version of that from the beginning. And our *Ultraman* theme is built off the original," Tindle said. "Scot is great at interpolating themes and it's awesome when it comes together."

Tindle was then inspired by a band called Polyphia, from Plano, Texas, whose superstar guitarist Tim Henson seemed perfect for *Ultraman: Rising*. Tindle called Stafford. "What do you think about having him play guitar?" Tindle asked. Stafford responded: "Give me ten minutes. I'm going to watch the link." Stafford then called Tindle back and said, "Here's what I'm thinking..."

"You have that level of collaboration with Scot, and you always know that he's going to level up. He's going to bring something extra. He's going to surprise you," Tindle said. "And he's one of the few people I know who could weave those really disparate ideas together."

"Guitar is a problematic instrument today," Stafford said. Just like the saxophone was for a while. Instruments fade away without much notice and are resurrected just as inexplicably. Stafford said that he didn't immediately say yes to using Henson. Instead he "orbited the sun for a few hours." Then he came to the realization that using Henson and his guitar could be perfect, in part because a guitar is not "an obvious thing to pull into a 2024 soundtrack." "But the way Tim plays it, it's almost as if he's reinvented it," Stafford said.

◄ Opposite page: When conductor Gavin Greenaway heard something he liked, he'd give a thumbs up to the folks in the booth.

▼ Ultraman faces off against Mecha Gigantron, not understanding what Emi already seems to know – that Gigantron is beneath the armor.

"He makes it sound like a totally new instrument." He compares Henson's sound to what Eddie Van Halen was doing in the 1980s. The electric guitar had been around for fifty or sixty years before Eddie Van Halen came in. Henson, Stafford said, "is in the same company."

Henson's creative process is unique – he will improvise things ("shredding," in Stafford's words), and then reassemble his guitarwork through a nonlinear editing process, where he is taking different parts and putting them back together. Stafford said that "half of his brilliance is his reassembling, he's almost like a DJ in that way." Henson ends up with "things that no guitarist would ever come up with." Henson would never come up with that playing in real time, but because he has labored over the process and figured it all out, it feels almost miraculous. "The way that he plays is really exciting," Stafford said. And more than that, it was perfect for *Ultraman: Rising*.

"It totally captured Ken being the greatest baseball player the world has ever known, and really cocky, and it fit within this very modern film in a way that I'm hard pressed to know how any other guitarist would've done that," Stafford said. "The way Tim plays was just so uniquely Ken, so uniquely Ultraman and so modern. It just doesn't sound like an electric guitar. And on top of that, Tim, for someone who looks like

▲ Guitarist Tim Henson workshopped ideas to add edge and momentum to the score.

▶ Inside the booth at AIR studios.

an animated rock-and-roll superhero covered in tattoos, I mean, cognitive biases be damned. I just wasn't expecting the guy to be so thoughtful, so sincere, so sweet, so professional." As Stafford knows too well, "rockstars really suck to work with ninety-five percent of the time." But Henson was a dream collaborator.

Stafford knew exactly where to use Henson too: he wanted the guitarwork to symbolize Ken "at his two peaks." The first peak would be him as a rockstar baseball player. And then his second peak would be towards the end of the movie, as he has rediscovered his confidence. But instead of it being an empty egotism, Ken is now full of purpose and power, thanks to his relationship with a surrogate *kaiju* child. "First it's about shredding and, 'Check out how awesome I am.' And then it comes back and it's like, 'Okay, no, this is a more fully realized human being,'" Stafford said.

Another element introduced into the score was a Vocaloid element, inspired by Tindle watching videos of Hatsune Miku, a character who exists by using the voice synthesizer software product, developed by the Yamaha Corporation and introduced in 2004. Tindle proposed yet another question: "What do you think about that as Emi's voice?" Two days later, Stafford sent a piece of music that he had done in Vocaloid, that was perfect for the *kaiju* baby. Even Henson, who, as we have established, is super tech-savvy, was impressed.

"You buy a character that this voice synthesizer model is meant to evoke, and they have an appearance and they have all this stuff," Stafford said. In fact, for a few weeks he was confused about whether or not he was even *allowed* to use it. Finally, Legal got back to him. He was cleared to use it. Game on.

▲ Color key by Sunmin Inn for Sequence 0100, "Where's Daddy?"

▶ Ultraman flying with Emi (and a hidden Professor Sato) on his back.

"What it was, was the sound of this old vocal synthesizer that is restricted to Japanese phonemes, but it's gibberish. It's a random series of syllables that it generates. It's not saying any words, it's randomized," Stafford said. "And there was something about the gibberish that just sounded like an extremely cute, extremely precocious toddler. And it is nothing that you can look at. There's nothing deeper than that." The musical sound of Emi was born. And it slotted perfectly next to the orchestral elements, the hacked video game music and Henson's devilish shredding.

Not that that was all. There was also a contribution from Thomas Wesley Pentz aka Diplo, the American DJ and producer who has worked with Mark Ronson, Sia, and Skrillex. Stafford said that he was "extremely happy when I heard his ideas," disclosing that the song came together fairly late and that he didn't work with the producer directly. Usually, Stafford said, he'd be biting his nails in the final mix, wondering where the song was and whether or not it was going to work. Then the song came in. And it was "really cool."

"To his credit, he worked with people in a way that rockstars don't usually have to," Stafford said. "A rockstar writes the music they want, and that's the end of it. But the fact that he was responding to notes and delivered what he did was really impressive. And I totally fell in love with it. It does feel like there's a lot that we pick up in osmosis. The feeling of the way that the film looks, the feeling of the music that he probably heard of mine, it all kind of got into that creative stew. "

Another unique element of the movie's music was how closely the composer and sound designer worked together. Tindle said that often they never actually meet. "I think it's why a lot of times it sounds like music and sound are fighting," Tindle said.

Instead, he had Stafford and sound designer Randy Thom – a legend in the business. Thom and Stafford had known each other from living in the San Francisco Bay Area. And Tindle was able to make it work, with producers Knott and Lisa Poole, to have them both start work early on. "Scot and Randy had been on board for almost two years before we were recording," Tindle said. They would sit in the theater at Skywalker Ranch and spot the movie together, talking about how to weave sound and music in the most effective way possible. "Having Scott and Randy work together, and they really like and admire one another, it just fell into place naturally," Tindle said.

"That's something that I'm very proud of, and it's one of the things that was really important for me to bring into this project because

▲ Scot Stafford, Shannon Tindle, Bret Marnell, and John Aoshima expressed varying degrees of excitement while having their photo taken at Fitzroy Tavern in London.

► A snap of Skywalker Ranch, where the final music and sound mix occurred.

it became one of my missions in life really," Stafford said. He had been scarred by an experience on the Pixar short "Presto," where he had to compose a score before any sound effects were added. For the short, he knew there was no reason to have him do a crash on the score, if the sound team would be putting a crash in later. "You want to have music do its thing, and if something is making an actual sound, let sound design do that. I was very much thinking about it," Stafford said.

He said that he was shocked to realize that sound design and score typically become a "volume war of who wants to be louder." This happens all the time, he said. In fact, Stafford built an entire company around how to integrate sound and music into the process more painlessly. Stafford said he was amazed that, on *Ultraman: Rising*, while he didn't control the process, he was working with Tindle, "the ultimate champion where it was just as important to him as it was to me."

And Stafford stresses that the specialness of the *Ultraman: Rising* music, this glorious sonic stew, couldn't have happened without Tindle. "The way Shannon makes you feel like family and the way he genuinely has your back," Stafford said. "He really sets the tone and expects you to do your best work ever, which we all did. You'd be surprised how many people worked on this stuff and felt, 'this is some of the best stuff I've ever done.'"

Actually, it's not that surprising.

▼ Members of the music, scoring, conducting, and film teams gathered on the floor at AIR Studios to celebrate the conclusion of the recording session.

THE
SOUND

It helps if Randy Thom, one of the most celebrated sound designers of all time, is on your movie early.

This is the man whose first film was *Apocalypse Now* and who has won two Oscars – one for *The Right Stuff* and another for *The Incredibles* – and been nominated fifteen times. (Since winning for *The Incredibles*, he admits, he's been a little pigeonholed in animation.) *Indiana Jones and the Temple of Doom*, *Wild at Heart*, *Backdraft*, *Contact*, *Harry Potter and the Chamber of Secrets*, *How to Train Your Dragon*, *Crimson Peak*. These are just a few of the films that Thom has worked on, all of them full of sonic landscapes unlike anything else in cinema. And if you get Thom to work on your movie, please do it early.

"I always lobby to get involved as early as possible whenever it makes sense, and it usually makes sense to some degree, but I almost never need to be on full time. I just need to, in some cases, just be essentially a consultant throwing sound ideas at the director and working out concepts," Thom said. "The main thing I always have in mind is that sometimes an early sound idea can really affect the way a live action movie is shot, or at least a given scene is shot. In the case of animation, it can often have an even greater impact on the way that the animators work."

▲ Leff Lefferts in front of the sound board during the final mix.

▶ The Skywalker Team and filmmakers posed with special guest Tim Henson during the mix.

◀ Ultraman, aka Christopher Sean, manned the sound board for a picture.

For *Ultraman: Rising*, director Shannon Tindle wanted Thom early to help guide the sound of Emi, the baby *kaiju* Ken is forced to raise. She's a nonverbal character, so the animators needed a guide for how she was going to communicate and how she would move. And Emi was unique in that she was something that had no real counterpart in the original series. She was brand new.

Thom said that he was aware of *Ultraman*. He wasn't an "aficionado" but he knew enough. "I knew about the various series that had been done and was vaguely aware of the sound style," Thom said. He paused to say that all visual storytelling has a sound style as well as a visual style. And one is just as important as the other. "As a sound designer and specifically a creature voice specialist... I'm always listening to how other people have done creature voices especially," Thom said. "I've read a little bit about how some of that work was done on some of the earlier versions of *Ultraman*, and I could make some educated guesses based on what it sounded like. Obviously this is part of tradition in Japanese cinema that goes back to Godzilla for a certain kind of style in terms of creature vocal design."

Ultraman has some iconic sounds, which Thom and his team could utilize. "At the same time, you always want to build on the original in a respectful way because the audience that knows about *kaiju* knows that they have a certain kind of sound, and you don't want to just start from zero and try to redesign something," Thom said. Gigantron, for example, is a new *kaiju*, which gave them some "leeway in terms of coming up with something new." Still, they didn't want to totally reinvent the wheel. "We still wanted to keep it in the same universe," Thom said. When it came to recreating some of the original sounds, Thom and his team had a similar philosophy, particularly with the iconic echo that accompanies his transformation. For Thom it had to be "a little bit bigger, a little wilder, more powerful."

One of the challenges Thom faced was the question of Emi's size and how that would impact the way she sounded, from Ken's perspective. "We know that she's huge compared to a person, certainly. And we had this balancing act to perform where we had to give the impression that she was big to the degree possible with the sound, but she also always needed to sound like a baby. And those two things are contradictory," Thom said. He should know. He's faced it before, dealing with dinosaurs and dragons that are young but still powerful. "It's still bigger than an elephant, but it has to sound cute in a way. There are tricks that you can do using reverberation and emphasizing frequencies to make a creature sound, but still retain some of that kind of cuteness, and lovability, and the thing that makes you want to hug them." Thom did a lot of experimenting to figure out what that balance was and how to make it work. Emi is arguably the most important character in *Ultraman: Rising*. If Emi didn't work, none of it would. "In the end, we certainly leaned in the direction of making her sound lovable, and adorable, and cute, because that was job number one," Thom said.

Thom also worked closely with composer Scot Stafford early on to avoid some common mistakes. "It's almost always the case that sound designers and composers have the best of intentions in the beginning of a project to work together and to avoid stepping on each other's toes, which is an ever present danger, but for a variety of reasons, mostly that both parties are so crazed and busy just trying to do what they need to do within their own departments, that often not as much actual collaboration happens as should, but in this case, it really did," Thom said. Tindle and Aoshima knew how important it was and insisted on sound and music collaborating early, something that Stafford and Thom agreed with.

▲ Ultraman himself supervised the mix, and was never far from the sound board.

▲ Gary Rizzo was captured mixing the final battle.

"The form that took was that we would send things to each other starting from very early on. He would send musical sketches for certain sequences to me, and I would send sound design sketches to him. And that allowed us to do several things. One is to kind of map out the audio spectrum to some degree in terms of who was going to be contributing what. For instance, in some areas, his score is more base and the sound design is more treble so that the two are not just obliterating each other," Thom said. "There are sequences where sound design leads a little more. There are sequences where music definitely leads. You often don't have this opportunity to start early and to do these kinds of experiments, the director often just kind of blithely assumes that it can all be worked out in the final mix. And the director tells the sound designer and the composer basically to bring all their ammunition to every scene, and that's usually a nightmare. You wind up pulling your hair out. We were very lucky on this project that we could avoid that."

What also helped Thom was that Tindle wrote sound effects into the draft. Not only that but Tindle also wrote how characters are hearing sound, "establishing a sonic point-of-view for each

▶ Gary Rizzo's chair was almost as recognizable as he was.

▼ Leff Lefferts hard at work.

▼ This picture was captured moments after the team completed the final mix.

▲ On the last day of mixing, Kristina Morss and Bishop Woodley showed us their tradition of dressing up.

sequence." (Tindle said that the sound effects were inspired, in part, by the amount of comic books he reads. *POW! BOOM! CRASH!*) "One of the most powerful kinds of sound sequences is one that is told from a character's point of view, because when it happens that way, then it gives you, as a sound designer and as a filmmaker, a lot more latitude to be stylized; the audience, whether they realize it consciously or not, gets the message that what they're hearing is being filtered through the mind of the character," Thom said. "You're not necessarily bound to have everything sound absolutely realistic because the audience thinks, 'Oh, well, that's how Ken is hearing this,' which is great for me. And it's great for the composer because then we can make everything musical in a sense, and just deal with feelings, and emotions, and tonalities, and not worry so much about trying to completely recreate a believable world."

And for a movie with careening *kaiju,* and giant robots, and building-sized superheroes, it was the quieter moments that could get tricky for Thom. There's more weight on his shoulders to make sure the audience buys these subtler moments. "That moment when Emi first comes out of the egg is fairly subtle, sonically, and very important to the film because we needed to establish her as this delicate, lovable character right off the bat," Thom said. "We had to be very careful not to clutter that sequence with extraneous sounds that didn't need to be there. And so you play tricks with the audience's perception by doing things like cheating down the sound of the ocean when this happens." Earlier, Thom had established the sound of sloshing waves. Twenty or thirty seconds before the moment when she comes out of the egg, he started lowering the level of all of that sound, so that the audience can focus on the two or three sounds that are actually important – the egg splitting open, for one, and her vocalization, a tiny newborn hiccup. "We spent quite a while working on that sequence," Thom said.

Thom said that the vision for *Ultraman: Rising* remained consistent through production. They talked a lot about Emi, they would send him storyboards or animatics, and occasionally Thom would throw some early sound effects in there. Discussions would continue, always about the story, and the emotion, and what the audience should be feeling. The overall style of the movie, Thom said, was "exaggerated realism with fantasy elements." This carried over to the baseball sequences, even. Heightened but believable. He compared it to the work he did on *Indiana Jones* and *The Incredibles.* "It's not sci-fi, but it also has to sound exaggerated, larger than life," Thom said. Sounds about right.

▶ Color key by Nacho Molina for Sequence 3400, "Call In The Expert."

ACKNOWLEDGMENTS

This book would not have been possible without the encouragement and cooperation of Shannon Tindle. Shannon isn't just a world-class filmmaker, who has made something incredibly special with *Ultraman: Rising*, but he is also one of the loveliest people you're ever likely to meet. This book came from our shared love of making-of books and the desire to document the process and people behind the movie. I spoke to over two dozen people who worked on the movie and, without fail, every single person would say it was the highlight of their career. If they had been in the business a long time, this statement was even more exceptional. Those just starting out were worried that *Ultraman: Rising* will have ruined them, because no future project would be as fulfilling. People cried to me over Zoom recounting their experiences on the film and how much the project meant to them. I get it. Working on this book was an absolute pleasure.

And, not to inflate his ego too much, but this gratitude, from everyone involved in *Ultraman: Rising* (myself included) began and ended with Tindle, a man whose kindness, patience, and understanding is only equaled (if not outdone) by his immense creative genius, his encyclopedic knowledge of pop culture and fine art, and his unparalleled ability to sum up a character in a few expertly placed brush strokes (or medium of his choice). I feel very lucky to know Shannon. I feel even luckier to call him a friend. He is, simply, the best.

My heartfelt thanks goes out to the entire crew of *Ultraman: Rising*, including (but not limited to) John Aoshima, Tom Knott, Lisa Poole, Marc Haimes, Scot Stafford, everybody at Industrial Light & Magic, the entire cast, and every artist who agreed to chat with me. You trusted me with your stories. I hope I didn't blow it.

Special thanks goes to the incomparable Maddie Lazer, who connected me with everybody and endured an endless stream of emails and Zoom invites (all of which she wisely turned down). This book, and, I suspect, the movie, wouldn't have been produced without her.

Thanks to Laura Burgess at Titan, who weathered blown deadlines, oversized word counts and my general nervousness as we tried to get this book done in time without either of us being hospitalized.

And thank you to my wife, Katy Everson, who endured me being stuck at my computer after hours and on the weekend for months. She is my favorite superhero — beautiful, brilliant, artistic, and endlessly inspiring. Without her support, I'd probably still be working on this thing. Also thank you to our rescue dog Nova, who is the light of our lives. I owe her some extra walks, I'm sure.

Big thanks goes to my mother Eileen Bellamah, who supported my love of art and animation from a young age (and who still does) and my siblings Kina, Alexa, and Gray. This movie is about how your family, no matter how strained or fractured, is really what matters. I am so lucky to have you all.

Drew Taylor • Toluca Lake, California